LEWES
The Postcard Collection

Bob Cairns

AMBERLEY

First published 2015

Amberley Publishing
The Hill, Stroud
Gloucestershire, GL5 4EP

www.amberleybooks.com

British Library Cataloguing in Publication Data.
A catalogue record for this book is available from the British Library.

ISBN 978 1 4456 4128 7 (print)
ISBN 978 1 4456 4140 9 (ebook)

Typesetting and Origination by Amberley Publishing.
Printed in Great Britain.

CONTENTS

Acknowledgements 4

Introduction 5

SECTION 1 From the Air 7

SECTION 2 Malling 11

SECTION 3 Cliffe 19

SECTION 4 School Hill 32

SECTION 5 Upper High Street 39

SECTION 6 St Anne's 51

SECTION 7 Southover 61

SECTION 8 Nevill 73

SECTION 9 Elsewhere 80

SECTION 10 War and Peace 96

SECTION 11 Bonfire 106

SECTION 12 Fires And Firefighters 110

SECTION 13 Street Parades 116

SECTION 14 At Leisure 120

Bibliography 127

ACKNOWLEDGEMENTS

All of the postcards in this book are from my collection. Edward Reeves & Son, however, own the copyright for the images on pages 16 lower, 93 lower and 102 upper and I'm grateful to Tom Reeves for allowing me to use them.

Bob Bonnett, Linda Cairns, Ben Evans, Chris Evans and John Kay have been helpful.

INTRODUCTION

There are three questions that I am frequently asked. First, are you a Lewesian? Second, what is a postcard collector called? And third, why do you collect old postcards?

The first has a straightforward answer. I'm not a Lewesian, but I worked in the town for thirty-nine years and, in my retirement, am still in town at least three days a week. I was born in Newhaven and through my interest in family history have discovered an uninterrupted line of ancestors there since at least 1658. As I have also lived in Ringmer since 1970 I hope I can be looked upon as a local.

Many Newhaveners, including my family, have been drawn to Lewes. We came up to the weekly market and especially at Christmas, to the cinema, to bonfire (as a young boy I stood on the window ledge of Fitzroy House to better see the United Grand Procession coming down School Hill), for the district sports at the Dripping Pan, for football at the Paddock and to watch the local football derby between Lewes and Newhaven on Boxing Days and Good Fridays when special trains would be laid on. Many also came up to the Grammar Schools but, unfortunately, not me.

The second question is easy also easy to deal with but gives an unusual answer. Postcard collectors are called deltiologists, a strange manufactured word which originated in 1945 and is based on the Greek for writing tablet study. My wife says that it is also a synonym for anorak.

The third question takes more consideration but is, perhaps, best answered by the contents of this and my other books, particularly *Lewes Through Time*. I collect cards of the local area because they trigger something in me about belonging. I realise that they largely present a rose tinted view of life a hundred years ago but, nevertheless, they evoke for me a sense of time and place that is easier to reflect through images than using hundreds of words. There was a popular song which contained the words, 'if a picture paints a thousand words' which sums it up better than I could. It is also why the postcards in this book dominate each page with a few facts and snippets to join them together and lend continuity.

During my preparations for compiling this book I have read again many of the excellent books and guides about Lewes. I have been able to use local and national websites to gather information and in spite of this research I doubt I am presenting any new information about the town. What I do know is that many of the images herein have not been seen before and even Tom Reeves was impressed by their high quality. A number of excellent photographers are featured but Edward Reeves and Son, established in 1857 and of which Tom is the fifth-generation owner, is the only survivor.

Cards by Reeves don't feature strongly as they worked largely on portraiture and commercial commissions but those by James Cheetham and Bliss & Co. predominate. Their quality and depth of field is startling and I could not match them or the perspectives when I tried to replicate their photographs for *Lewes Through Time*. I didn't carry stepladders in the sidecar of my motorbike either which is how the staff photographers from the Metzotint Co. captured the angles. They also encouraged as many local people, and especially children, to appear in the photographs to boost sales. Bob Elliston told me how, as a young man before the First World War, his father worked for Metzotint and had to rush the negatives for a local event to their York Place, Brighton works. Within two hours, and based on an estimate of the size of the crowd, sufficient cards were produced and he returned to sell them 'hot off the press'.

James Cheetham is my favourite photographer of that time with his distinctive white italic titles and I have over 400 of his cards. Kim Clark wrote about him in *Lost Lewes* and as an amateur photographer who worked at Lewes prison he quickly saw the opportunity which the Edwardian craze for postcards presented. He was not alone and both national and local suppliers quickly entered a market which saw up to 400 million cards a year being posted in the UK between 1902 and 1918, the so called Golden Age of Picture Postcards.

Lewes is a special place and I hope my selection of cards reflect it well. It was difficult to choose the final 240 cards from my collection of 2300 but most have not appeared in any book before while others are old favourites. Similarly it has not been easy to fully profile the town in a small volume. However, by highlighting its distinct traditional areas and events I hope that, modestly, I have presented you with a more than acceptable volume which justifies the epithet *Lewes: The Postcard Collection*.

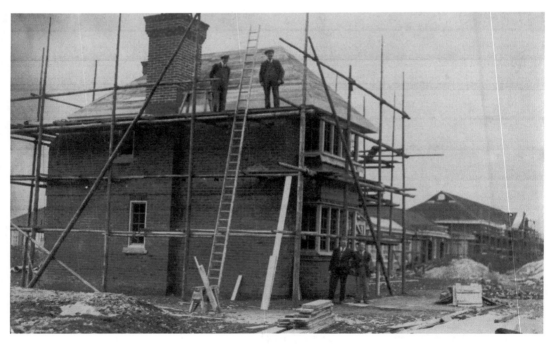

Lewes County Secondary School being built by Ringmer Building Works.

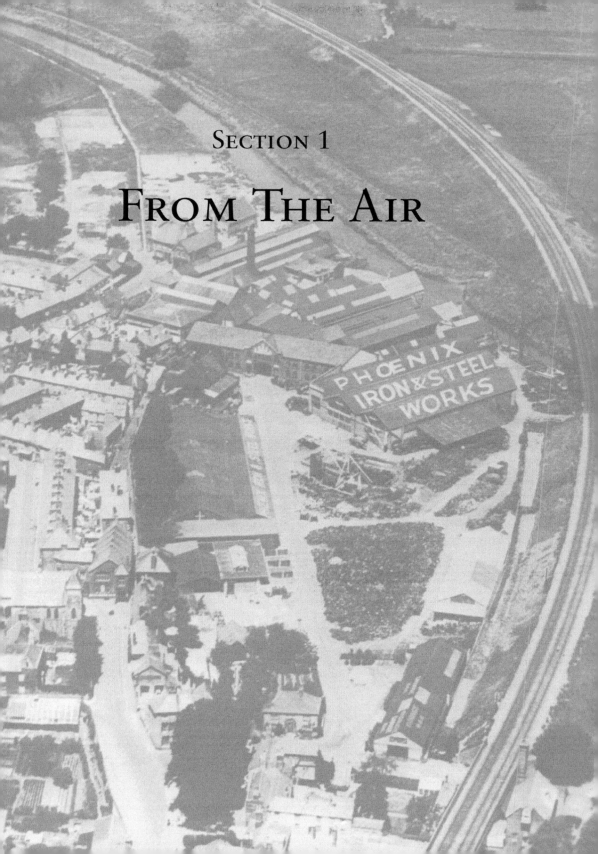

SECTION 1

FROM THE AIR

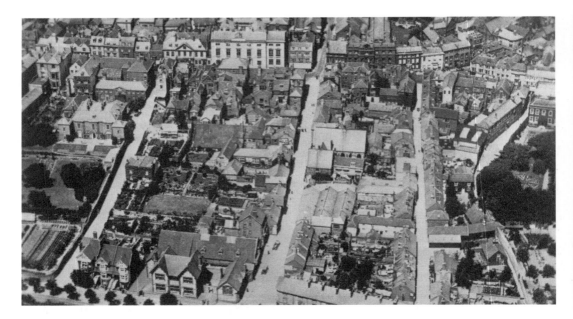

The card on page 7 gives a splendid view of the North Street area dominated by Every's Phoenix Iron Works. Adjacent to the west is the railway line to Uckfield which closed in the 1960s. Above, Station Street is seen running up the middle of the card and appears distinctly wider than it now seems as do both St Andrew's Lane to the left and St Nicholas Lane to the right. Below, Market Street and North Street take the eye as they sweep down to the river. The surrounding network of streets was largely removed by slum clearance between the wars. The long-awaited redevelopment of this area is currently being hotly debated.

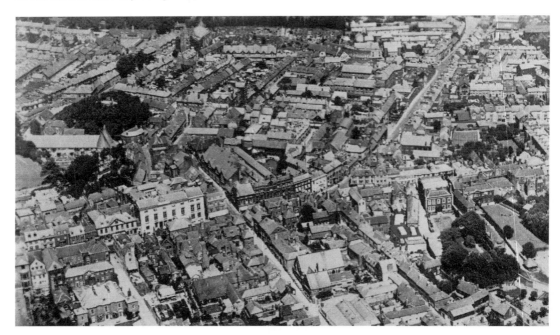

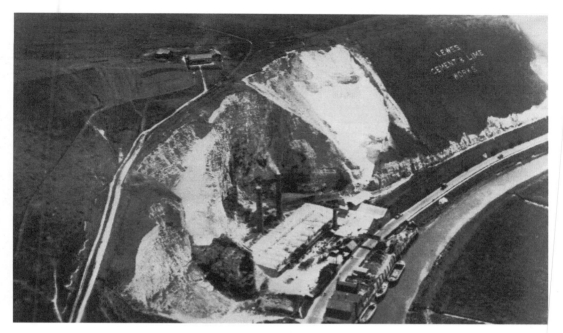

The top photograph was taken from above South Street where the Cuilfail Tunnel exits towards Southerham. 11 is situated atop a chalky Chapel Hill and below sits the Portland Cement Works and its wharfage. Below is pictured the top of School Hill and the then recently erected War Memorial (see page 105). In the lower left corner is the prominent Baxter's Printworks in Walwers Lane and which was largely destroyed by fire in 1960s. The Maltings, owned by Beard's Brewery, and later the County Record Office, are in the top right corner.

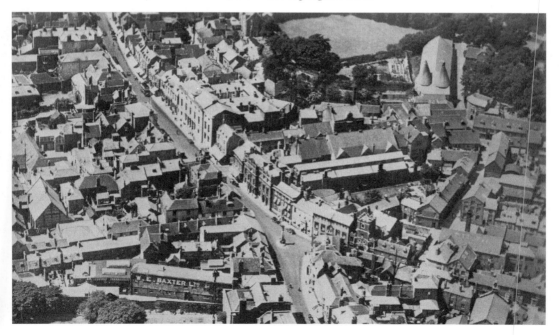

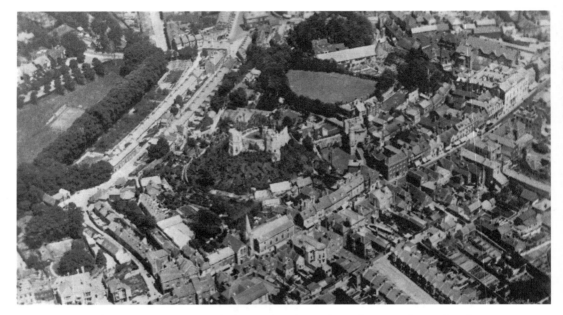

Both postcards show central Lewes and the Castle. Above, from the west, the castle takes centre stage with the bowling green beyond. Below attention switches to Brack Mount probably the site of a temporary wooden fort built first by William de Warenne. The cards in this section, taken over ninety years ago, give interesting perspectives and emphasise the town's compact nature and high-level development within the walled burgh. They also set the scene for our perambulation which carves its way first through the town centre and then into the incorporated parishes and those being developed.

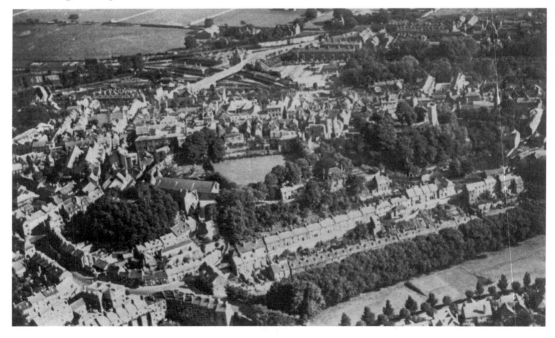

SECTION 2
MALLING

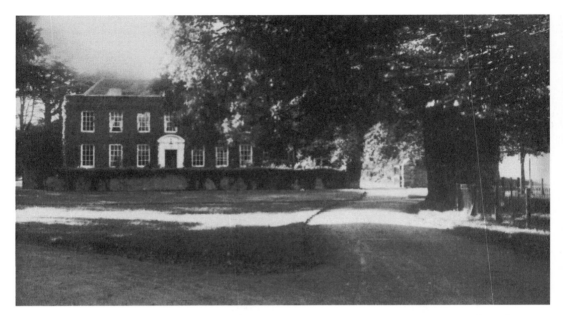

Malling House in Church Lane is now the Sussex police headquarters. Rebuilt in 1710 by John Spence, whose family had acquired the previous building on the site in 1656, it had been owned by the Archbishops of Canterbury until the Reformation. Reginald Powell, a land agent, owned it in 1911. It was described as 'an elegant and spacious building' and Pevsner said it's nine-bay façade 'stretched comfortably'. The fine eighteenth-century summerhouse peeking over the wall can be seen from Old Malling Way. The Deanery was formerly a collegiate building and, rebuilt around 1700, was owned by John Stansfield and William Kempe in the seventeenth century.

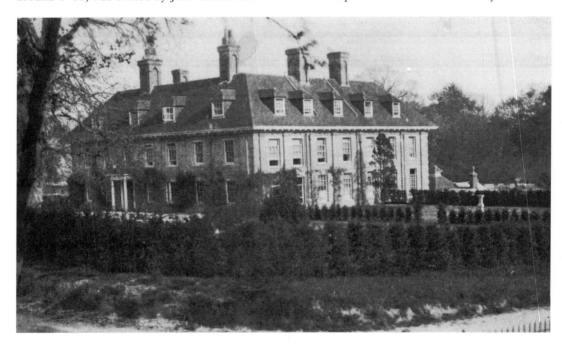

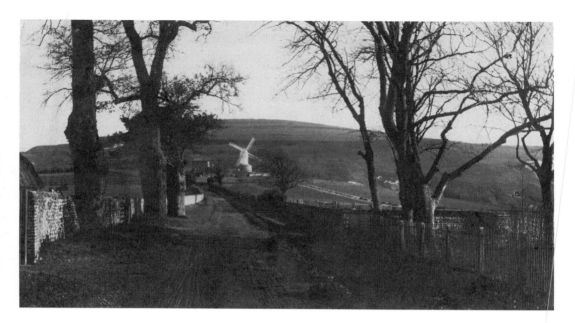

The view up Church Lane was taken from opposite the turning into Fitzgerald Road. Malling Windmill (see the following page) stands in isolation beyond the main road in Mill Road. It was no longer used for milling when the photograph was taken in 1905. When considered with the view below we are reminded of the lack of development to the northwest of the town. Malling and Old Malling farms were not to be developed until the 1960s and Spences Lane stands out clearly. So does the Grey House, owned by Miss Rickman, of the Quaker brewing family, and the burial mound of her favourite horse Charlie.

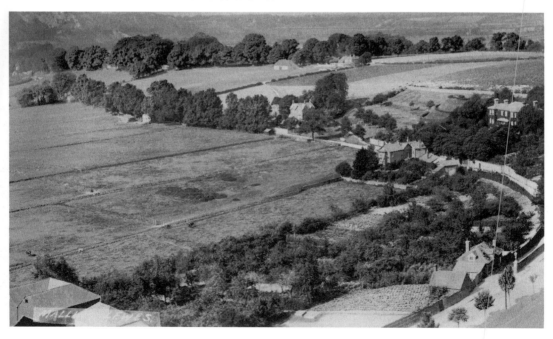

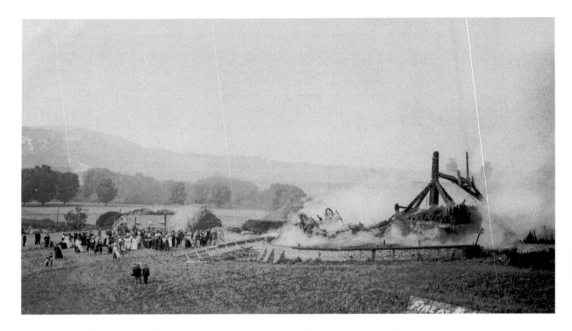

Malling Windmill burned down on 8 September 1908. It had ceased its original task of corn crushing some years before and was being used by the Lewes Sanitary Steam Laundry as a store. A new telephone alarm system had been installed in May 1908 and provided five call points throughout Lewes. This was the first fire notified using the telephone at Cliffe Corner. Although the Borough Brigade made a swift response and used a thousand gallons of water, the fire was too advanced and was left to burn out. The bottom card shows the site the following day looking down from Mill Road to Malling Church on the left.

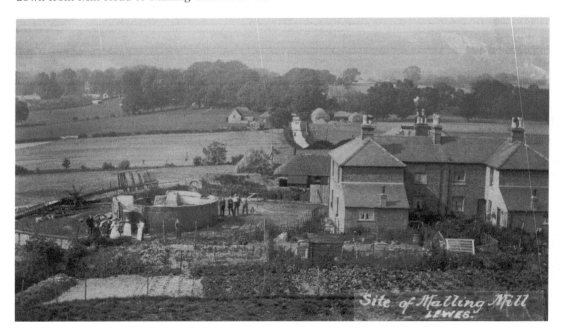

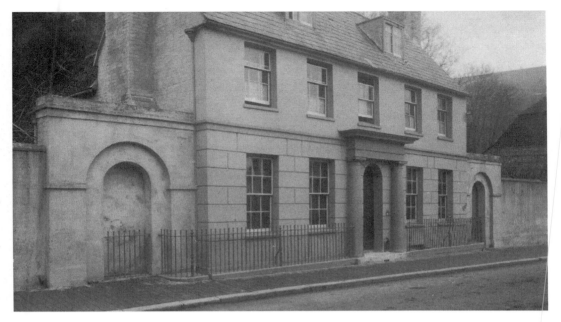

Known as The Master's House, this building at the bottom of Malling Hill was next to the workhouse the entrance to which was through the arch on the right hand side. The finer arch to the left was knocked down when a house was built next door. Further down, and opposite the Esso garage, is the smart Coombe House which James Berry, a local builder, built for himself in 1822. Beyond, and second in the row of cottages, was the Malling sub post office (shown in close-up on page 11). Fanny Chambers, the postmistress and stationer/confectioner, stands in the doorway of No. 113 and was assisted by her unmarried sister Florence.

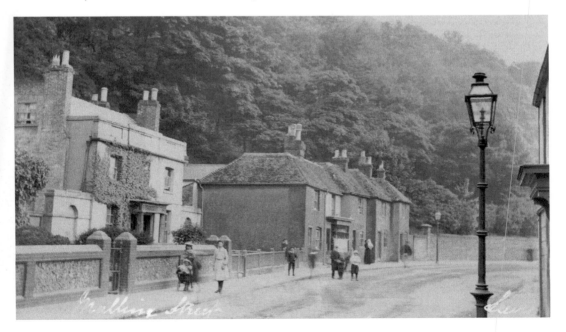

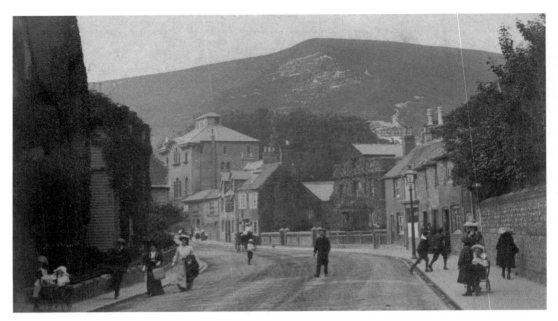

Looking back to the Coombe on the right is the boundary wall of Cliffe and All Saints Cemetery which is now under the dual carriageway approaching the Cuilfail roundabout. The sub-post office was in the terrace, which survives, and is now called Penny Black Cottage. The Wheatsheaf, Brewery Tap and Elmsley's Brewery are beyond an ivy-covered Coombe House in the middle ground. The Jireh Chapel below is seen from an unusual angle. It was built in 1805 and a giant pulpit dominates a superb galleried interior which has recently been beautifully restored. More than 400 children attended Sunday school here in the 1880s.

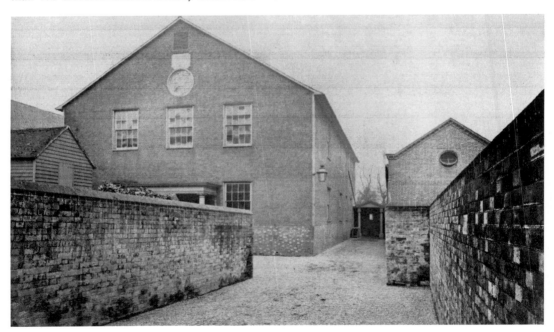

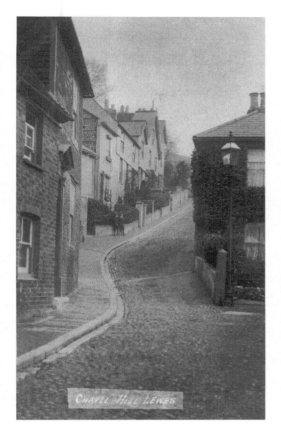

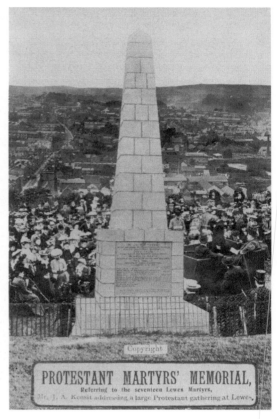

PROTESTANT MARTYRS' MEMORIAL,
Referring to the seventeen Lewes Martyrs,
Mr. J. A. Kensit addressing a large Protestant gathering at Lewes.

Chapel Hill, previously known as East Street, leaves Cliffe Corner and rises to the Golf Club from where it links to the down land routes to the north and east. The chapel from which it obtained its later name was on the left hand side. The Martyrs' Memorial above Cuilfail was unveiled on 8 May 1901 by the Countess of Portsmouth. The memorial was raised by public subscription and, following a collection on the unveiling day of £49, there was still an outstanding balance of £56. The foundation stone had been laid in October 1899. The obelisk commemorates the seventeen Protestant martyrs burned to death during the Marian persecutions.

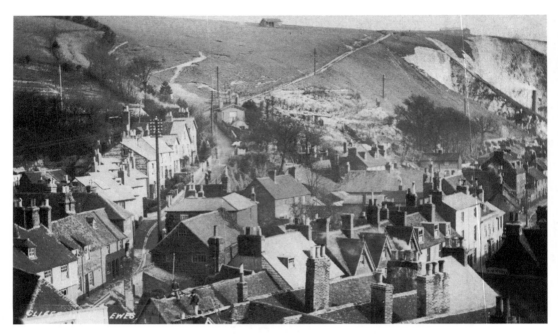

The roofscape photograph gives an interesting view from Cliffe Church along South Street to the cement works (see page 9) and up Chapel Hill to the Golf Club. The last house on the right is shown below. It is possibly the site of the Cricketers Arms from the early days of cricket when the game was played on the top of the Downs, close to the old second green of the golf course. In the foreground are the path and gate which led into gardens created on a chalk terrace by Thomas Baldy in the mid-eighteenth century and gave panoramic views over the town and along the river.

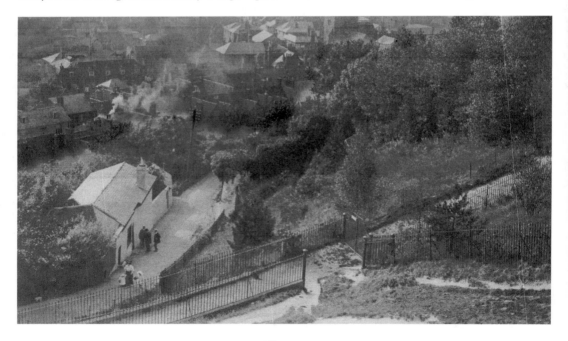

SECTION 3

CLIFFE

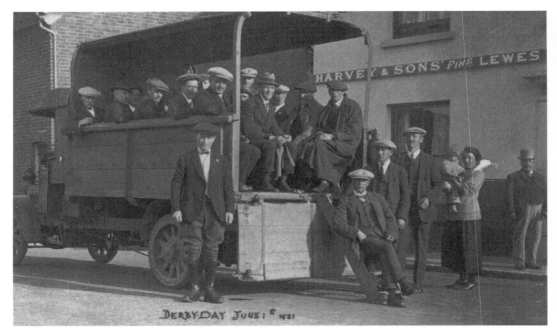

DERBY-DAY JUNE 1ˢᵗ 1921

As a main route into Lewes, South Street had always been a busy road until the opening of the Cuilfail tunnel. It had its share of pubs to meet travellers and to provide for those who worked at the two cement works and along the river particularly in the timber trade. Above can be seen a group preparing to leave for the Derby in Epsom in 1921. Their luxurious transport is outside the thatched house which was No. 37 before being replaced by terrace houses. Nearby the contestants prepare for one of the famous wheelbarrow races held between 1903 and the First World War. The miniature wheelbarrows were pushed as far as the top of School Hill and back.

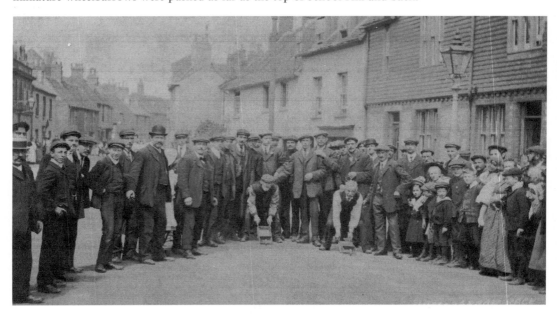

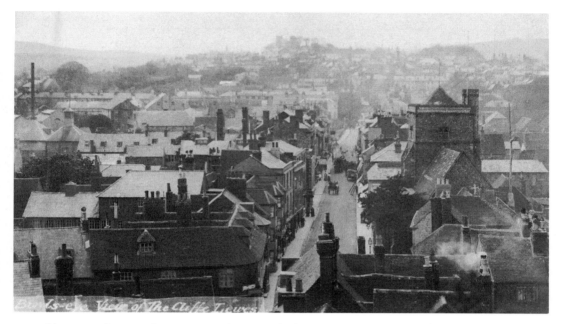

Above can be seen the causewayed approach that was the only river crossing in Lewes before 1968. Cliffe High Street, formerly West Street, remains narrow and clogged with traffic in spite of being largely pedestrianised. St Thomas' church (see page 19) is of the twelfth century although records only began in 1320. It contains a copy of the charter of Henry IV which gave Cliffe (or 'at Clive') its market. Below can be seen Gilbert Watford, the butcher at No. 28, at the start of the High Street. His shop and Shaw's Stores on the corner were demolished to provide the small car park at the crossroads which was so busy that it required a policeman on point duty.

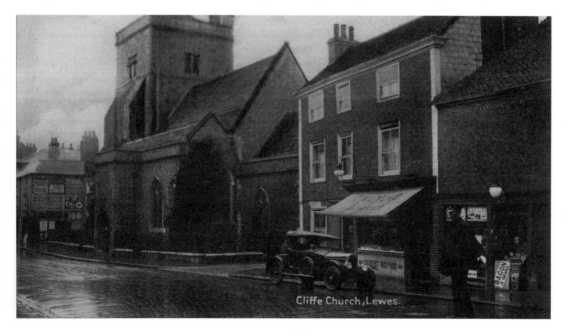

Cliffe Church, Lewes.

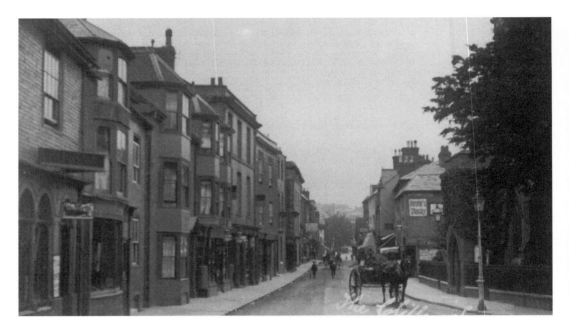

Opposite Cliffe Church was a characteristic run of local businesses. At No. 33 was Frank Firmin, an ironmonger, at No. 35 Percy Skinner, watchmaker, and at No. 39 the coachworks of Albert Cook and Joseph Rice. Nos 33 and 35 were demolished and replaced by the Odeon Cinema. Below, looking back to the crossroads, cattle can be seen being taken to market. The coachworks were faced by another butcher and the pole beyond belongs to Bennett the hairdresser who also had a shop on St Anne's Hill. Radstock House, just seen on the left, built in 1890, was then, as now, occupied by veterinary surgeons.

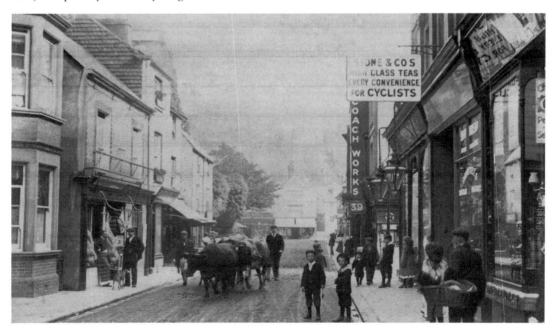

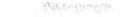

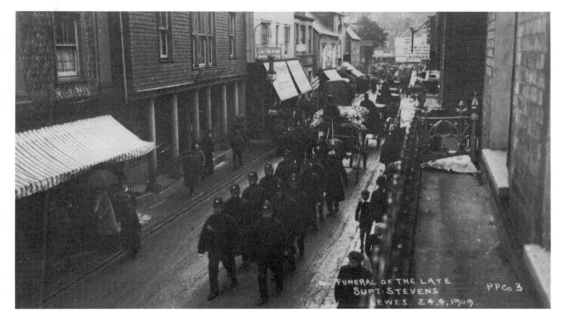

FUNERAL OF THE LATE
SUPT. STEVENS
LEWES 24.4.1909.

PPCo 3

The funeral cortège of Superintendent Harry Stevens passes along Cliffe High Street in 1909. Harry had run the Lewes station in West Street where he lived with his wife and three children. On the left, at No. 18, are the well-known premises of Elphick and Son, run in 1911 by Samuel Elphick who lived above the store with his wife, two sons, widowed mother, aunt, sister-in-law, and a domestic servant. The business survived until a few years ago and the building is now leased to the Real Eating Co. Next door was Thompson's drapery business (see page 115) and opposite the International Stores with the staff posing outside.

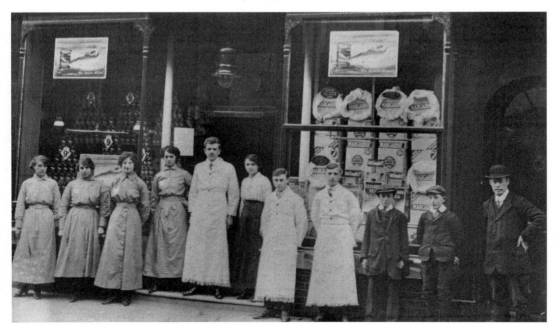

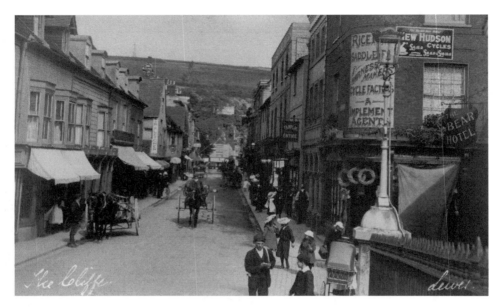

The view above is from Cliffe Bridge right back along the High Street to Commerce House on Malling Street. The clarity of the shot is as good today as it was when taken in 1906 by James Cheetham. The premises of Rice Brothers Saddlers & Harness Makers, are on the corner of Bear Lane and next door was the Worlds Stores pictured below. These shops are now Bill's. Next along was the Cliffe Tavern and, at No. 50, another pub, the Castle, which is now a betting shop. Almost opposite were the Beehive beer house (licensee Henry Newnham) and the Cliffe sub-post office run by Fanny Scrase. The only pub in the street now is the Gardeners Arms at No. 46.

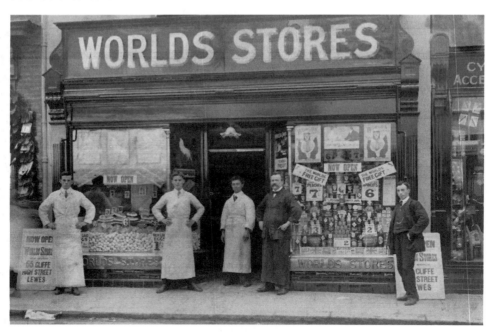

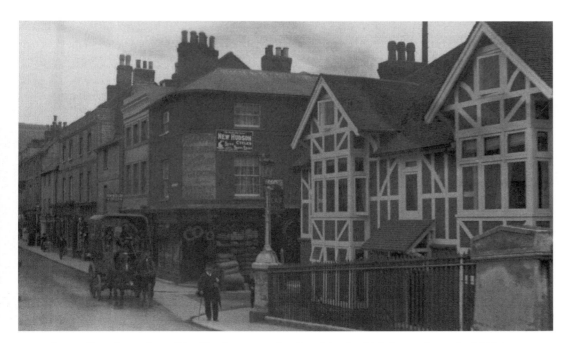

Across Bear Lane from Rice Brothers was the Bear Hotel which burnt down in 1918 (see pages 113 and 114). It had served as the administrative centre for Cliffe before it was incorporated into the Borough in 1881. An inn for at least 300 years it was also the wool exchange for the town where farmers and merchants faced each other across the table until deals could be struck. The main stables at the rear, for up to forty horses, were lost in the fire but the staff accommodation and additional stabling on the other side of the lane survived. These became the shop and offices of Harvey's Brewery and are now the John Harvey Tavern.

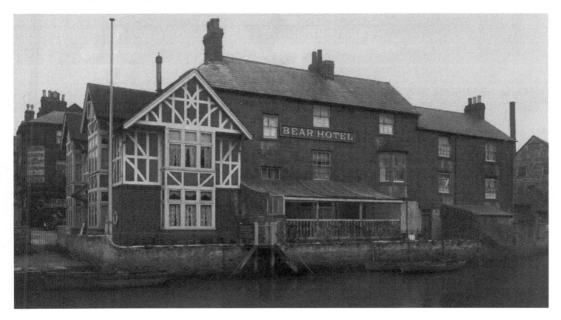

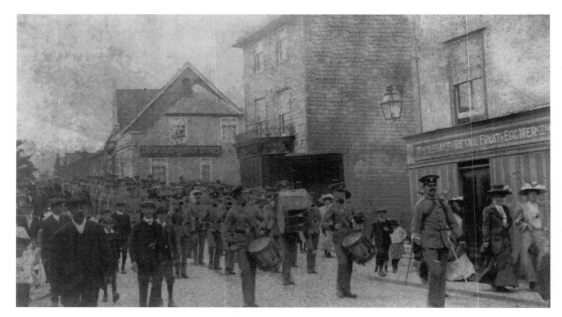

Above soldiers are marching into Cliffe making their way to the Malling camp. On the right is a fruit business which later became Wilmhurst's, Savage's, a record shop, the Cliffe Bazaar, Radio Rentals, James Barnett and now the offices and shop of Harvey's. Across the lane was Edward Kenward's jewellery business. He lived above the premises with his wife, three children and a domestic servant. The business was later owned by the Clark family who still trade across the river in the old Co-op Stores building. Below, the Riverside centre, then Martin's Garage, is seen across the river and, in the distance, the old railway bridge to Uckfield.

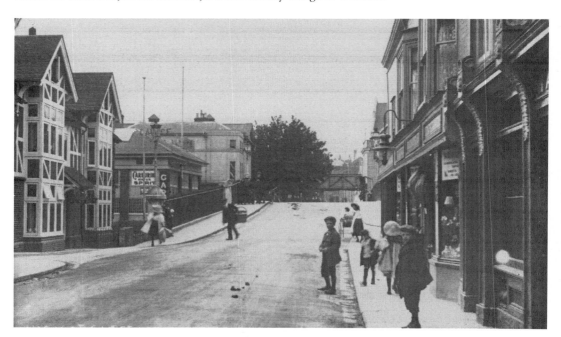

In 1900 the Borough Council decided not to
establish a municipal electricity company and
entered instead into an agreement with the
Electrical Power Association Co. This company
built their 'model works with a mathematical
correctness' on a one-acre site in Bear Yard
adjoining the river. There were two sets of engines/
dynamos and four distributing stations at
St Anne's, Cliffe Corner, the junction of Fisher
Street and High Street and on the Offham Road by
Landport Lane. The works had twenty permanent
staff under the management of Mr J. S. Frain.

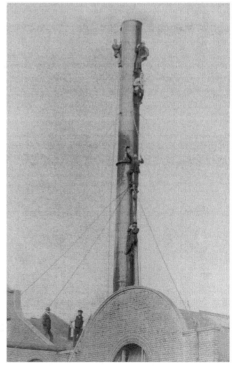

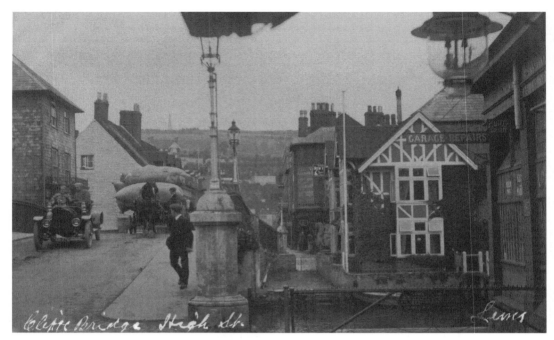

Another fine card by Cheetham captures the emerging menace of motor vehicles and their impact on this compact town which has still not been resolved, even with a bypass, after 110 years. I'm not sure where the wagon carrying hops is going as it has just passed the entrance to Harvey's; maybe to Beard's Maltings on Castle Banks or their Star Brewery in Fisher Street. Harvey's had used Foden steam wagons to make their deliveries for a number of years and below is the newest addition to their fleet in around 1920. Established in 1790 Harvey's are the sole survivors of the nine breweries which have been in the town over the centuries.

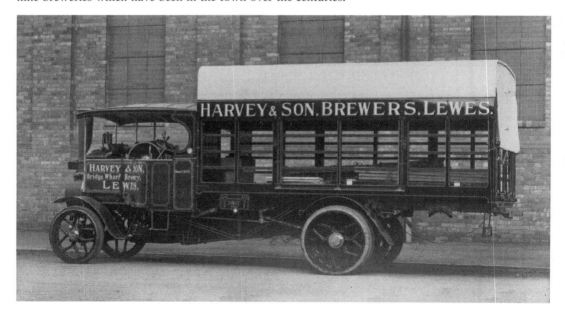

28

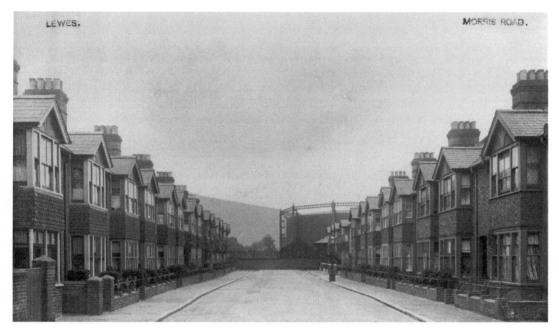

The gasworks were established in 1822 on a site in Timberyard Lane which had been the Polhill & Gibson Iron Foundry. Their two gasometers built in 1869 were a familiar sight across the Lewes landscape and especially at the end of Morris Road. Ebenezer Morris acquired a foundry in 1823 in nearby Foundry Lane which closed in 1890. The following year land behind the premises was developed and, very creatively, the road of terrace cottages was named after the family. Below is a typical tradesman's delivery cart owned by William Smart a butcher of the Cliffe.

The card above actually shows the start of Lewes High Street which stretches from the river to St Anne's Church. Bridge House has been refronted and is now occupied by Clarks Shoes and an optician's shop. Below is the Fitzroy Library erected in 1862 by the widow of Henry Fitzroy, who was MP from 1837 to 1860. She was the daughter of Baron Rothschild. It was run by trustees who leased it at a peppercorn rent to the Lewes Library Society. In 1897 the Borough Council took responsibility and it was the town library until 1956 when it was sold to the Franks family (who sympathetically restored it) to meet the cost of the new library in Albion Street.

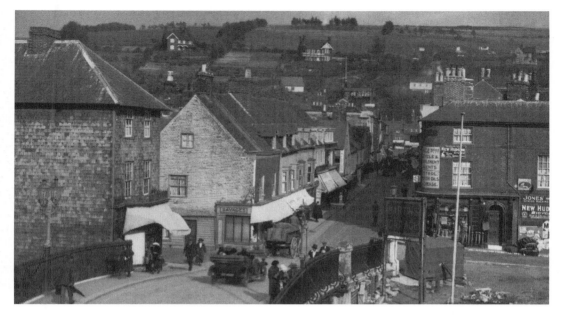

These cards illustrate Cliffe High Street in the late 1920s, top, and 1950s, below. Newcomers to the town find it difficult to appreciate how, as the only way in and out of Lewes before the opening of the Phoenix Causeway, traffic was able pass in both directions and especially across Cliffe Bridge, which was reconstructed and widened in 1932. Though traffic could pass, it was not without the slightest accident or breakdown, as now in the upper High Street, causing colossal jams. On the right side of the upper card the cleared site of the Bear Hotel has not yet had J. C. Martin's art deco garage built on it (now the Argos store) and the Martyr's Memorial stands clearly on Cuilfail.

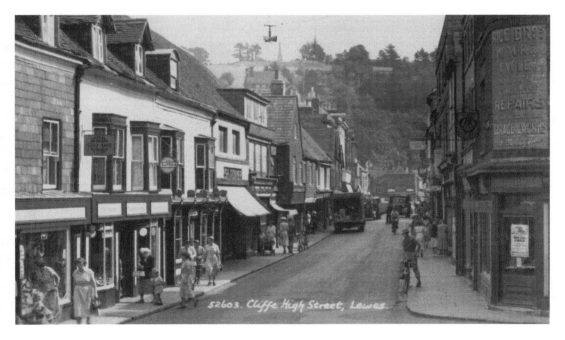

52603. Cliffe High Street, Lewes

SECTION 4

SCHOOL HILL

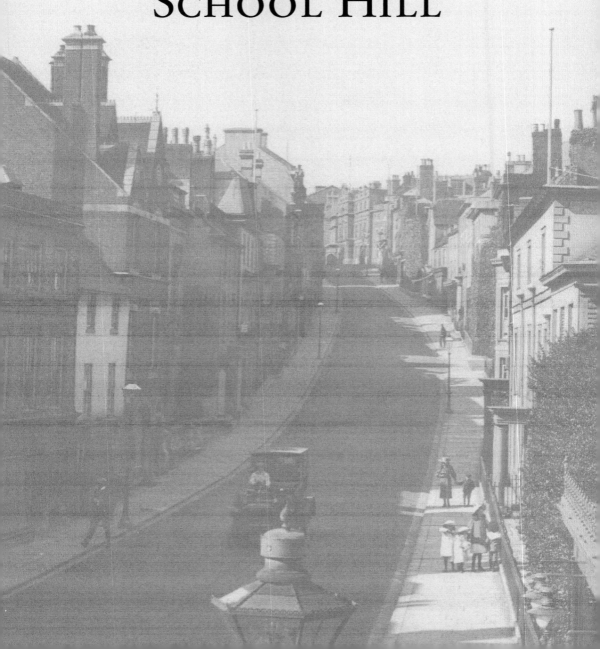

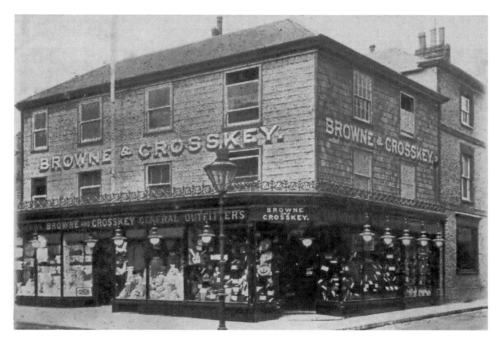

At the base of the hill was Browne and Crosskey's quaint department store. The postcards were used for advertising and the lower one reads,

Our Drapery department is doubled in area and filled with new goods for the season. A choice selection of dress fabrics in the new designs and shadings. Blouse materials in almost endless variety. The flannels and flannelettes were bought early and are splendid value, there is both quantity and quality. The assortment of household linens, sheetings, calicoes, quilts, blankets, &c comprises goods from the best manufacturers. Hosiery and underwear for all. Special show room for ladies' coats, skirts, blouses, corset &c. An early call will oblige. [sic]

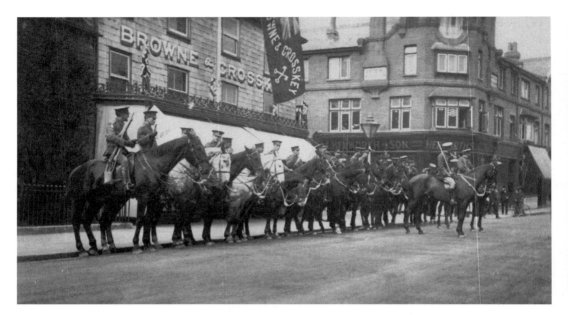

The steepness of the School Hill incline is shown on page 32; Mr Cheetham must have used an upstairs room in the Seveirg building to get the perspective. The hill looks much wider than it is with the absence of traffic and the photograph can be compared with that on page 37. Above can be seen the Sussex Yeomanry, who accompanied HRH Duchess of Albany (see page 74), parade in front of the store with the Seveirg Building beyond. The lower card shows it housed Hepworths Clothiers with Newington's, the Lime Burners, next door. There is a fine view of the railway bridge and the Martyrs Memorial stands starkly white in the distance on Cuilfail.

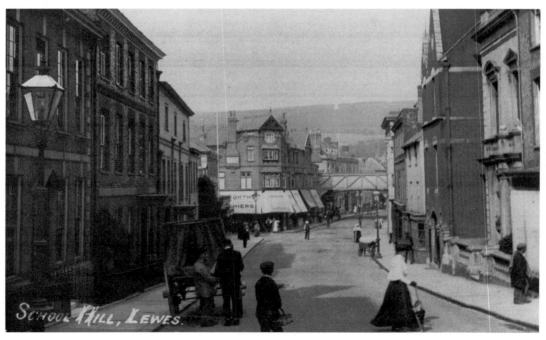

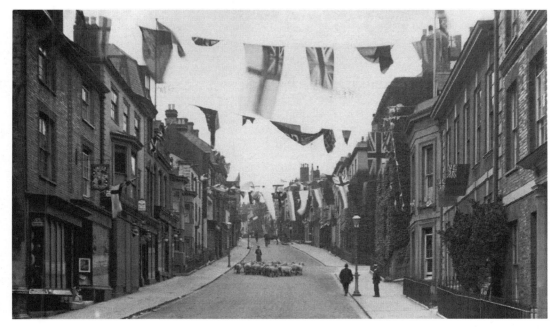

While there have been educational establishments on School Hill, including the Misses Hickson's Ladies School at No. 28, they were not responsible for its name. The first record of the name is in a 1498 rent roll and is probably a corruption of either Cole, or Cool Hill because of the wind, or Schole being Old English for shoe on account of its shape at the time before the slope of the hill was smoothed out. The decorations above are for the 1911 Coronation and in this early morning scene sheep are being moved across town. A keen eye will see that there is now a Temperance Hotel on the upper floors of the Seveirg Building.

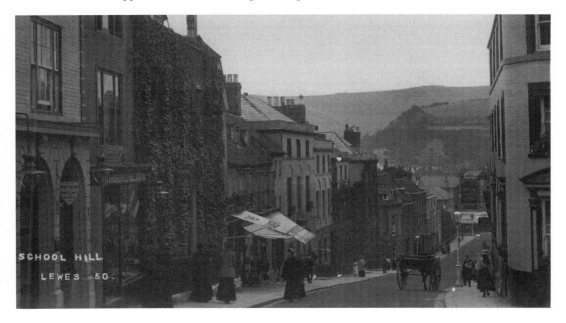

Albion Street was developed in the 1820s and cut through from halfway up School Hill to East Street, formerly Poplar Row. A Tudor Inn, the Turk's Head and its gardens, had previously been on the site, although the building was subsequently occupied by Thomas Frewen, the inoculation pioneer, and a school. The photograph below is taken from the junction with Carvill's shop at No. 24 High Street where more famously Clothkits was established in the 1970s and Wickle, one of my favourite coffee stops, now operate. Two doors up is the Cinema De Luxe, later to be run by the popular 'Fatty' Briggs.

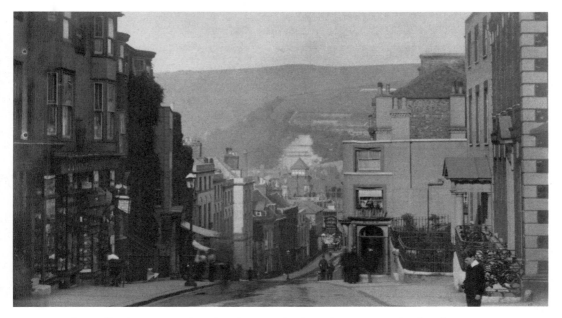

Douglas Miller has captured in the photograph above how steep School Hill appears every time I walk up it. Its still-excellent sharpness shows the tower of Harvey's Brewery in the distance and scaffolding around the building which is now owned by Clifford Dann and called Albion House. On the right, below the projecting shop of Head, is yet another Temperance Hotel – a surprising sight in a town of over seventy pubs! Below can be seen a hotel for the intemperate, renamed Bests, and the card shows perfectly how traffic flowed both ways on the hill although in the 1930s there wasn't so much of it. In the distance the allotments of Cuilfail are fast giving way to grand houses.

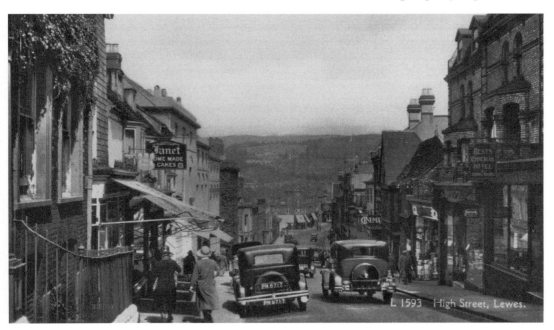

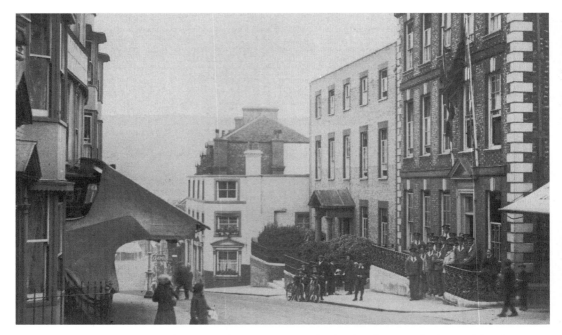

Many onlookers feature in the fine shot of Lewes House and School Hill House, both grand five-bay houses. Early in the First World War the latter was being used as a convalescence home for wounded soldiers who are wearing blue uniforms to denote their status. It was built in 1715 for a physician, Peter White. Lewes House was built a century later and was famously (or maybe infamously) owned by the dilettante Edward Perry Warren from 1889 to 1928. Here he had Rodin's *The Kiss* before briefly donating it to the town and then the Tate. Finally we look back on the ornate lamp standard, replaced by the War Memorial, and where St Nicholas Church had stood until the fifteenth century.

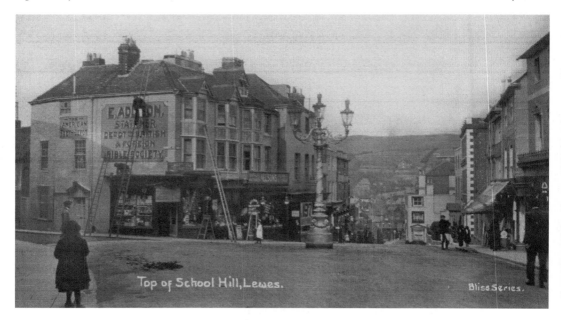

Section 5

Upper High Street

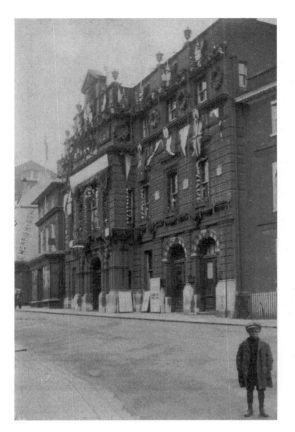 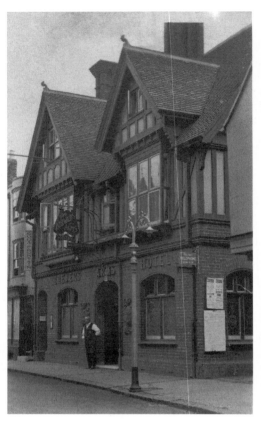

The two fine buildings at opposite ends of the upper High Street both replaced finer medieval structures. Above the town hall is decorated for the 1911 Coronation. It had been converted from the Star Inn in 1893 and refaced in 'very red' bricks which Pevsner disliked. In existence for 400 years, before it had been the centre of town business and social life. Catering for a different clientele was the Brewers Arms Hotel at the bottleneck. The shot above right by Bourne, an Eastbourne photographer, shows the licensee William Ashdown in the doorway. He had replaced Herbert Gower as the proprietor when it was rebuilt a few years earlier.

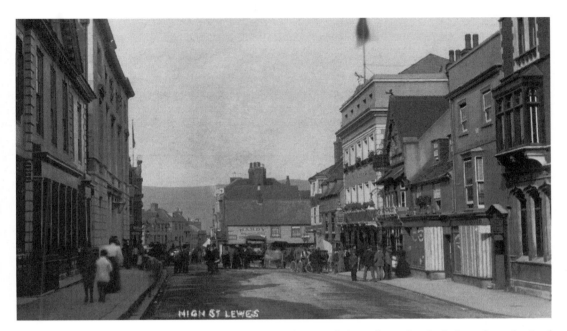

The White Hart Hotel was originally a town house of the Pelham family before they obtained Goring's house in St Andrew's Lane (now the Pelham House Hotel). The building had become a coaching inn by 1717. The upper card shows its important position opposite the Law Courts and County Hall. The Unicorn Inn next door had previously been the Three Pelicans and, earlier, a post office. Its name was derived not from the mythical animal but from a form of Victorian carriage. It has been occupied for more than eighty years by A. Wycherly and Son who were established in the town originally in Keere Street more than 120 years ago.

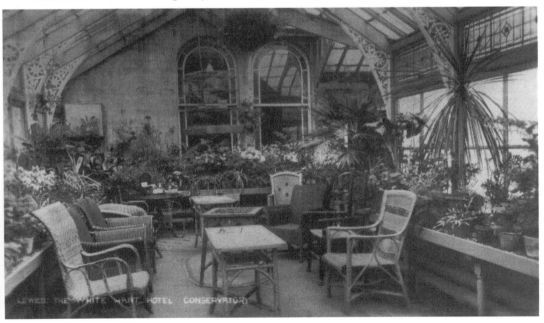

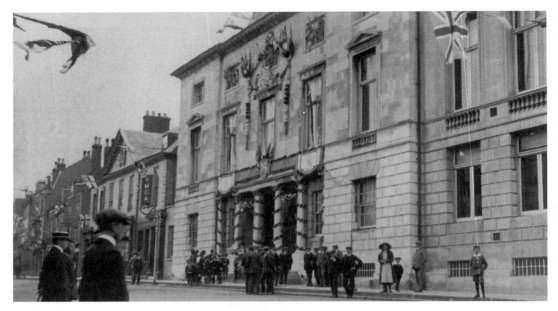

The old County Hall, now the Law Courts, was built in 1812 and is seen here decorated for the 1911 Coronation. It replaced a town hall and sessions house which stood in the middle of the street nearby. It was built on arches with the stocks and whipping posts nearby. With its fine interior and plethora of servants it seems to resemble a gentlemen's club. Next door was Newcastle House owned at this time by Benjamin Court, a Cliffe ironmonger. It became a school and then an extension to County Hall after rebuilding in 1928.

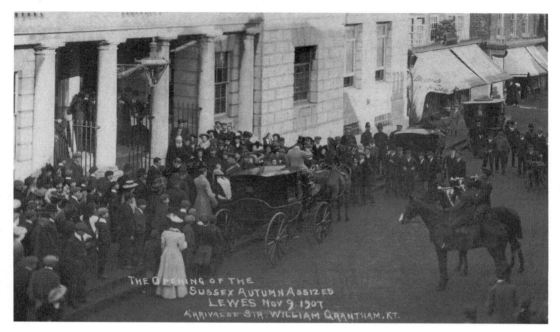

THE OPENING OF THE
SUSSEX AUTUMN ASSIZES
LEWES NOV 9. 1907
ARRIVAL OF SIR. WILLIAM GRANTHAM. KT.

Lewes has had law courts since at least the twelfth century and these cards show the Assizes' openings in November 1907 and February 1910. These were grand affairs with the judges accompanied from their lodgings via church to the court by a detachment of troops from Preston barracks, the High Sheriff, the Mayor of Lewes, Alderman and other dignitaries. The calendar for the 1910 session contained the names of twenty remand prisoners and included an attempted suicide, a butcher stealing nine pounds of beef from his employer and a railway porter who was imprisoned for two months for an offence against a fourteen-year-old girl.

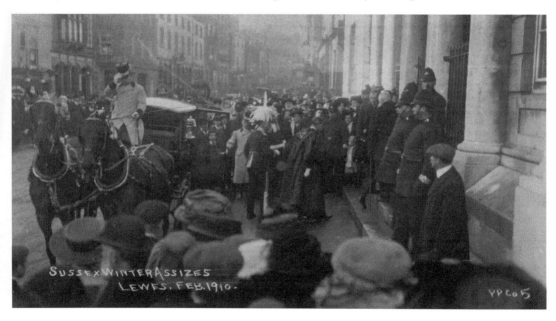

SUSSEX WINTER ASSIZES
LEWES. FEB. 1910.

YPCo 5

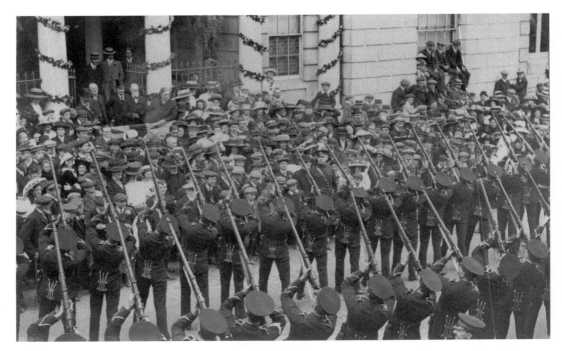

On Coronation Day 1911, soldiers fired a salute before the Mayor gave them, and the assembled children, a patriotic address on discipline and the maintenance of the Empire. Below, after the 1906 general election, Sir Henry Aubrey Fletcher can be seen as he addressed the crowd and thanked them for electing him as their MP. He had won elections in 1885, 1892, 1906 and 1910 shortly after which he died. He had been unopposed in 1895 and 1900. On 9 May 1906 the Lewes Conservative Association organised a complimentary dinner in his honour in the Assembly Rooms followed by a musical concert featuring Madame Edith Welling with Tom Gearing at the piano.

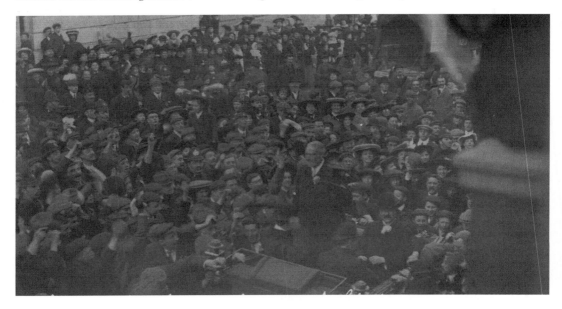

Moving along the High Street, the prime buildings to the right were occupied until a few years ago by Whyborn chemists. The card's message, from early 1914, says 'The best I could do for Lewes... Cyclometre 179 miles now'. In the photograph below we have moved 30 yards and have a closer view of the building newly erected following the Smith's fire in 1907 described on page 113. The County garage adjoins Barbican House and was later to acquire a petrol pump. Its neighbours include Eastman & Son and Blaber & Clary, who had been temporarily displaced by the fire and were drapers and dressmakers respectively and at No. 172 Edith Funnell who traded as a haberdasher.

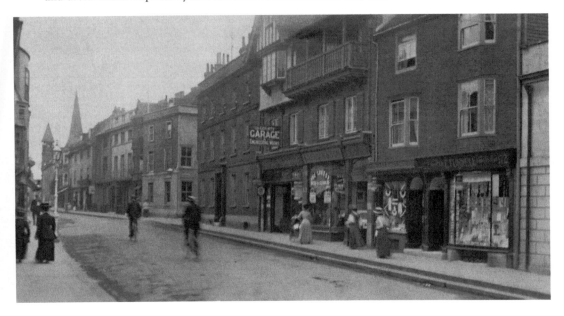

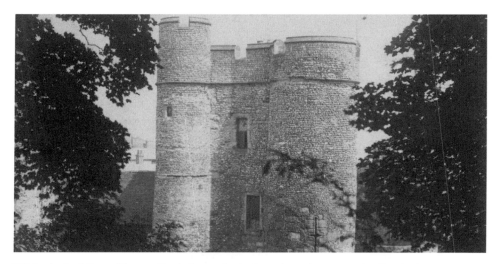

While the building of Lewes Castle began in the late eleventh century the fine Barbican was not added until the fourteenth. Built by the last of the de Warenne line, the castle moat had drawbridges and portcullises on both sides. The south front has the Lewes speciality of knapped and squared flints. In 1903 Castle Lodge became the home of the infamous Charles Dawson, the probable perpetrator of the Piltdown man hoax. He sent this card to his business partner G. E. Hart in 1907 and the solicitors' business they founded still operates in Uckfield. He had full trust in the postal service as part of the message reads, 'I shall be over by the 8.50 a.m. train tomorrow morning...'

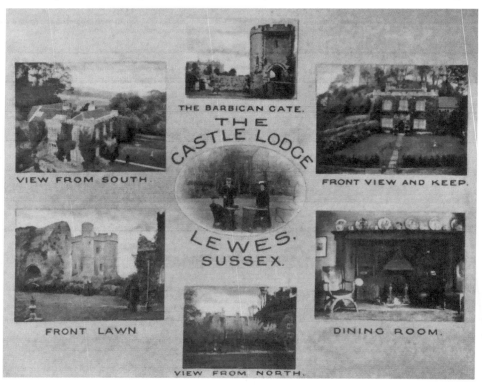

THE BARBICAN GATE.

THE CASTLE LODGE

LEWES. SUSSEX.

VIEW FROM SOUTH.

FRONT VIEW AND KEEP.

FRONT LAWN

DINING ROOM.

VIEW FROM NORTH.

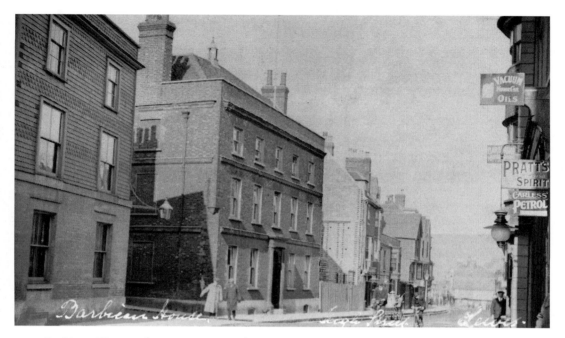

Barbican House, above centre, is a fine sixteenth-century timber-framed building which was enlarged and re-fronted 200 years later. It has a stone fireplace carrying the date 1579. It is the headquarters and museum and library of the Sussex Archaeological Society founded in 1846. Below is the opposite street view in 1912. The large poster on the side of the shop is advertising the Operatic Society's April production of *The Pirates of Penzance*. St Martin's Lane, seen off to the right, gives a reminder of the Parish which amalgamated with St Andrews in 1337 and which in turn was subsumed by St Michael's in 1545.

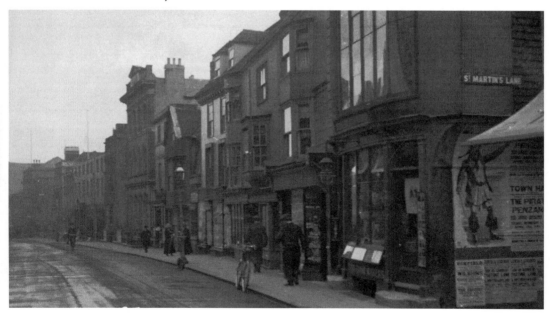

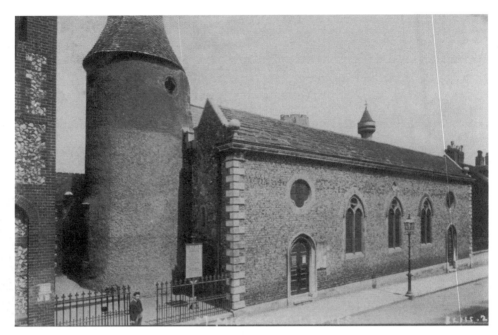

St Michael's Church is one of three benefices remaining from the original fifteen Lewes parishes and churches. The oldest part is the rare round west tower from the thirteenth century. Its north and south walls of knapped flints date from 1748 and are also a feature of the tower now, unfortunately hidden under pebbledash. Its two bells are dated 1571 and 1608, the latter cast by Edmund Giles who had a Lewes foundry. Its oldest brass monument is dedicated to a member of the de Warenne family, possibly the last, in around 1430. Its most famous wall monument is to the Pelhams and the verse praises Sir Nicholas for repulsing the French at Seaford.

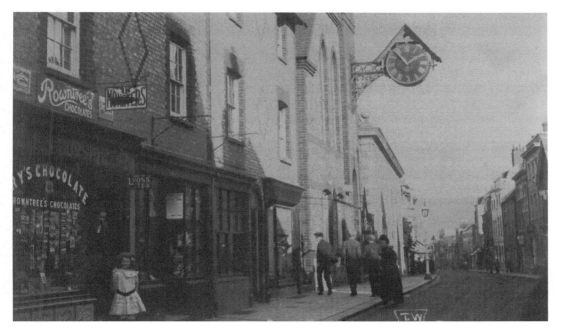

Along from St Michael's is the Freemasons Hall, rebuilt in 1868. It carries the clock which was on the clock tower beside the church's west tower. Substantial remains of the old fourteenth-century west gate of the town are in the basement which I was kindly shown recently by Ron Newth the Lodge Secretary. Opposite is Bull House in which Thomas Paine famously lived from 1768. In 1771 he married Elizabeth, the daughter of the owner Samuel Ollive who was a tobacconist. This interesting fifteenth-century building was restored by John Every, the ironmaster, who left it in 1922 to the Sussex Archaeological Society but little of the original interior remains.

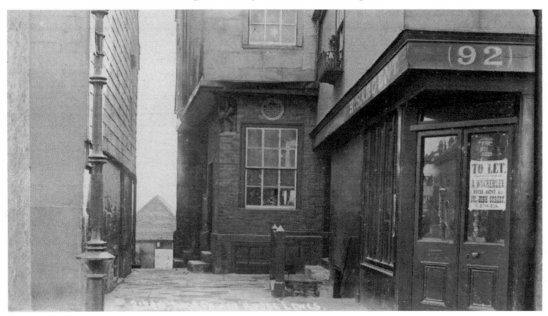

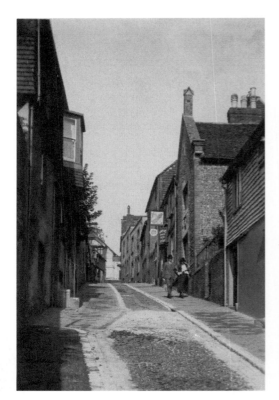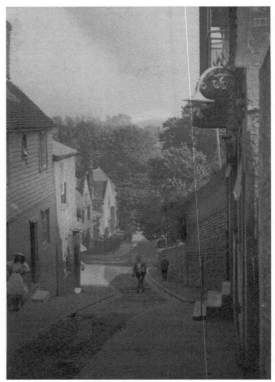

The Britannia Inn at No. 10 survived until the mid-1920s. The licensee in 1911 was Harry Winder who had eleven boarders. Beyond was Pinyoun, a baker and six almhouses for women which closed in 1960. Keere is a likely corruption of Cahors of the old British *caer* for a street in the fosse or ditch of a town wall. George IV, when Prince of Wales, supposedly drove a coach and four down its famous blue cobblestones on his way to the Grange. A desirable address now, in 1911 it was largely occupied by labourers and tradesmen except for a company director at Caprons and Charles Whiteman, Clerk to East Sussex County Council, at Dale View at the bottom.

SECTION 6
ST ANNE'S

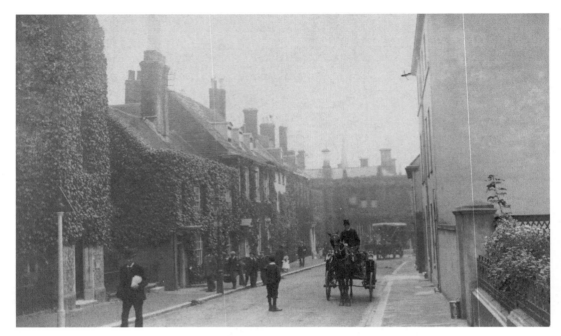

On the previous page the bottleneck provides a quiet gateway into St Anne's, but above takes on a more hurried aspect, although the boy seems oblivious to the traffic around him. A fine run of knapped flint houses merge into the Old Grammar School in the left foreground and where the red brick framings become yellow. From beginnings in 1512 Lewes Old Grammar School moved here in 1714 although the building originally endowed to the school became unfit for the purpose and was replaced in 1851. Further up the hill is Shelley's Hotel. The façade was remodelled in 1763 by Henry Shelley but the porch is dated 1577 and was rebuilt when the building was still the Vine Inn.

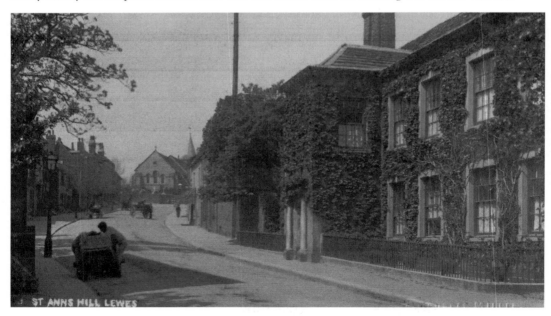

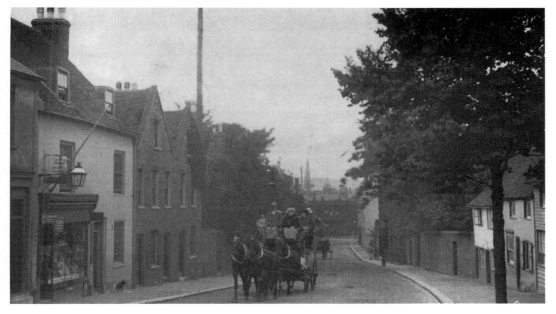

The stagecoach, *Tantivy*, climbs the hill passing the premises of John Bennett, the hairdresser, at No. 134 which, in 1941, became The Millers, a private house and artistic centre. It had previously been the Rose Tavern. The stagecoach ran day trips from the Old Ship Hotel in Brighton to the White Hart Hotel for lunch. On longer runs to London and Epsom famous people such as Sir Henry Rolls, Sir Albert Stern and Lord Lonsdale took its reins and those of the *Old Berkeley*, its sister coach. Below cattle are being walked down to the market and are passing on the left a beautiful run of houses of mixed architectural design including Hill Lodge and St Anne's House.

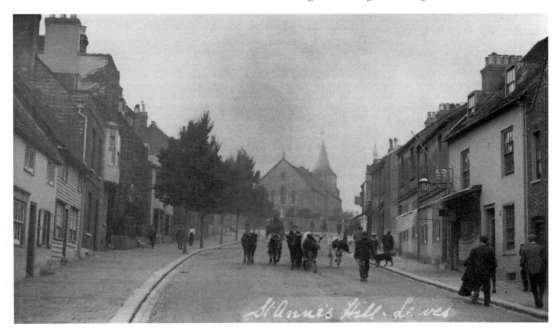

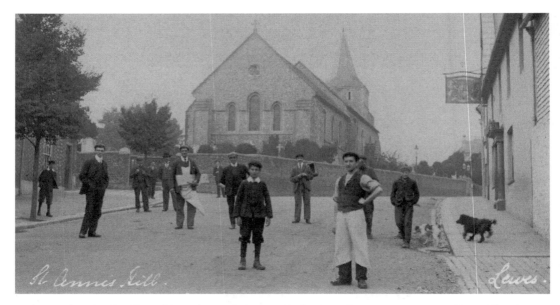

St Anne's church is highly visible in the card above and Cheetham has again encouraged lots of local people to pose for him. Formerly dedicated to St Mary, the earliest parts of St Anne's are twelfth century as is the magnificent basket-weave font. On the vestry site was an anchorite's cell which became the grave of the female recluse who lived there. Opposite is the Roman Catholic church of St Pancras built in 1870 and rebuilt in 1939. The fine cottages beyond were used as its school and were demolished to provide the new entrance. The Pelham Arms creeps into the shot on the right and is first recorded with that name in 1758, having been The Rose and The Dog previously.

The Meridian Line crosses Western Road beside the shop on the left now Sinclairs. Beyond is the sign of a used-cars dealer which became the County Garage and Caffyns. The area had not been much developed before the supply of piped water in the 1830s and the building of the prison with its reservoir on Race Hill in 1854. The dilapidated problem building, now known as the Cannon O'Donnell Centre, looks smart and imposing on the corner of Spital Road and beyond it are the cottages converted from the remains of the St Nicholas leper hospital and demolished to make way for the school extension in 1933.

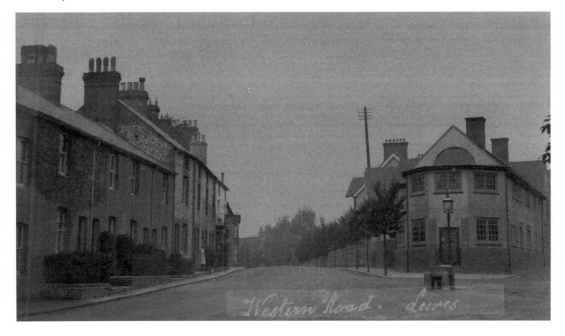

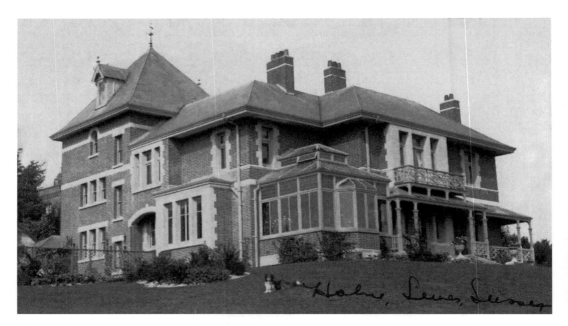

Holms, the grand house above, later renamed Warren House, was the westernmost house in Lewes when built opposite the prison in the mid-1890s. It was occupied by Major Lang, the Chief Constable of East Sussex, his wife and daughter and six servants. Its lodge house, which survives, housed his gardener/chauffeur and his family. Southdown House below in St Anne's Crescent, was the County Council's School of Domestic Economy before becoming the Library Headquarters in the 1930s. Lillian Webb the Head Mistress lived in. Originally known as Belle Vue House, Edward Chatfield, a timber merchant and co-developer of the Crescent, had it built in 1871.

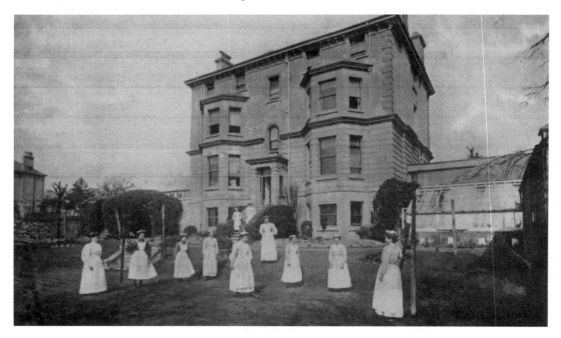

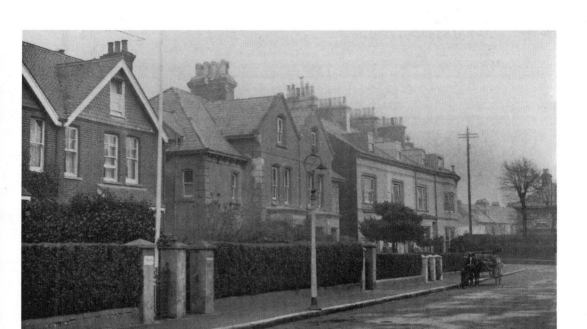

St Anne's Crescent was a cut above most of St Anne's Parish when its houses were constructed through the 1870s on Pesthouse Field. In the 1911 census of its forty-three houses, eleven were in multiple use and ten were boarding houses albeit for very middle-class lodgers. Five tradesmen or artisans were also listed but the majority of occupants were in the professions or had private means. At No. 10 lived three retired schoolmistresses, all unmarried sisters called Rudgewick, while at Nos. 1 and 8 were the artists Edwin John Earp and Clarence Alfred Earp. Most interesting for me is that James Cheetham, Clerk and Schoolmaster at the prison and great photographer, lived at No. 15.

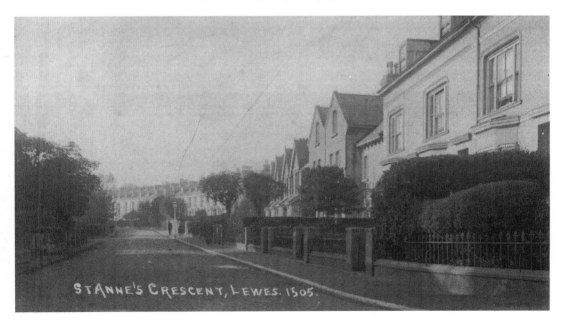

ST ANNE'S CRESCENT, LEWES. 1505.

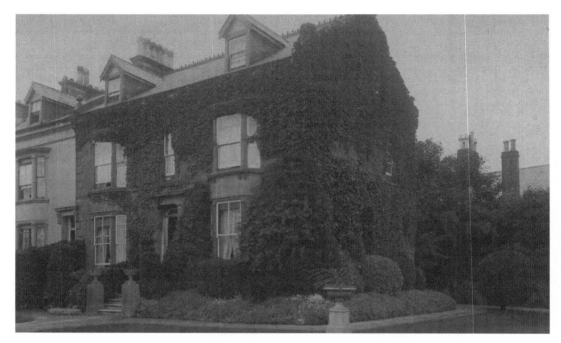

The Roberts at No. 24 were typical residents. As can be seen from their house, which, although not detached, is still a grand double-fronted building. Thomas Roberts lived there with his second wife of four years, a son and daughter, a cook and housemaid. Both children, and another older son who lived with five other shop assistants and three servants above the shop, worked in the substantial family grocery and provisions store at Nos 45–46 High Street at the top of School Hill. This prosperous family also had another shop, the Great Western House Stores, around the corner from their home and below pose in their spacious rear garden.

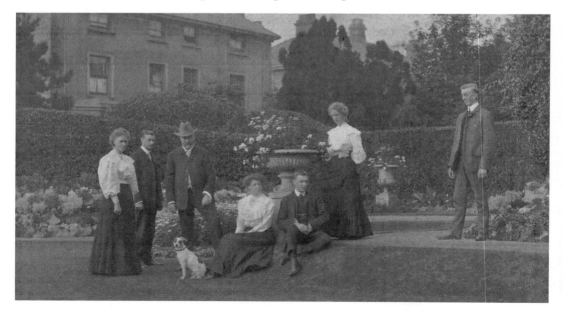

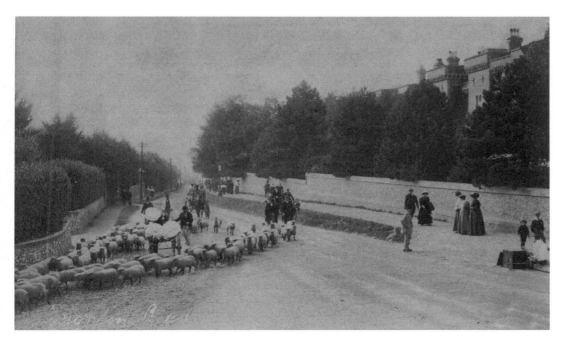

The bucolic scene above was at the western boundary of the town by the prison. A flock of sheep is turning into Winterbourne Hollow and, given the level of activity and the carriages, could have come from the annual Sheep Fair held behind the prison. Note the shoeshine on the right. Below is a more menacing view of the rear of the prison. The windmill is shown in a close-up on page 93. Lewes prison, or New Gaol and House of Correction to give it its full name, was completed in 1854 and cost £38,000. It replaced premises built in North Street in 1793 which quickly became overcrowded and unfit for purpose.

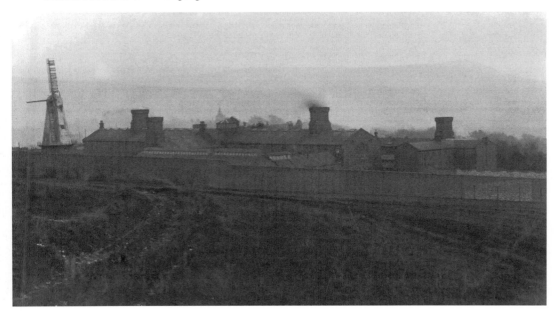

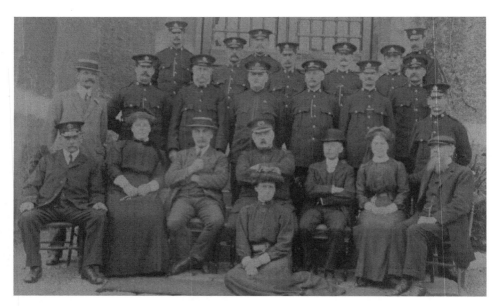

The prison staff in 1912 included female warders as, at this time, there were female prisoners in the upper floor of F wing. The card was sent by Harry Jackson, a warden, who writes, 'you will find me as large as life standing behind the girls where I always like to be...' Harry was one of the warders who lived in Leicester Road. In the 1911 census eighteen staff are listed as resident (although some might have just been on duty that night) including the governor, matron, chaplain, chief warden and cook. There were 185 inmates of whom fourteen were females who came from all over the country. Most were working class but I noted an accountant, tent maker, cigar maker, artist and journalist.

Section 7

Southover

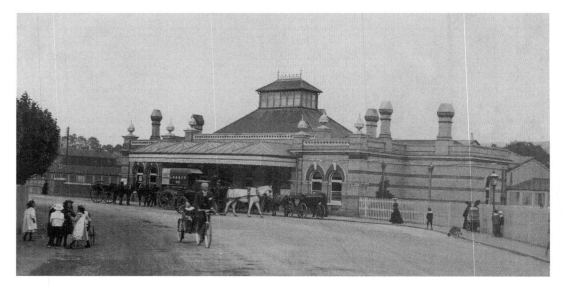

The Railway Station moved to its present site in 1857 replacing the first station in Friars Walk on the site of the soon-to-be-demolished Magistrates' Courts. It was described in a contemporary publication as, 'The building is in the Gothic style and its architectural features have a very pleasing effect'. This is contrary to the 1904 town guide which read,

> About the structure we need make no remarks as to its merits or demerits. It is interesting to narrate when it was being built some few years ago, considerable difficulty was found in laying adequate foundations for the structure owing to the subsoil being little better than a bog.

Well it's still there, so make up your own mind.

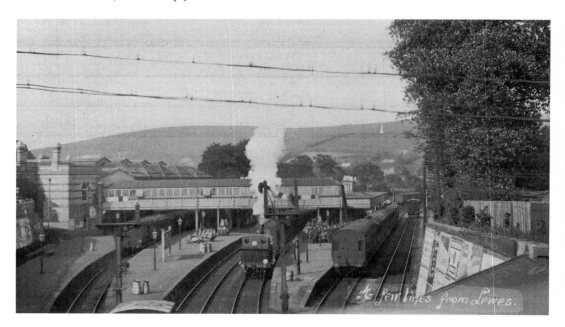

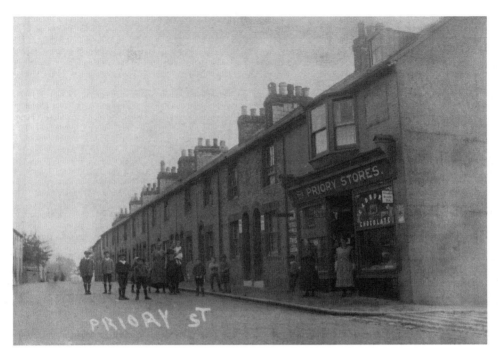

Until the new station was built and the road to it joined onto Priory Street the route to Southover was along by the old town wall (called Southover Road from 1885) and up Southover High Street by the side of the Grange. The top postcard looking east shows the old Priory Stores on the corner of Mount Street. It was formerly a small inn called the Priory Arms. Below, and fifty yards on, the view is largely of the cottages opposite although the sign of the Jolly Friars pub at No. 24 (licensee John Bell) is noticeable on the right. It closed in the 1960s. I am pleased to say that both of these scenes are recognisable today.

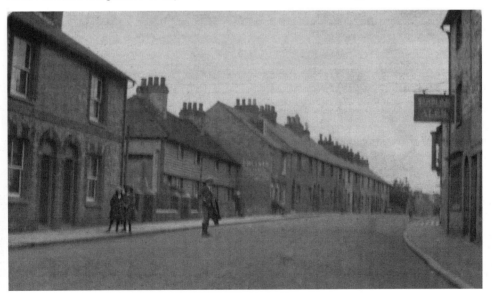

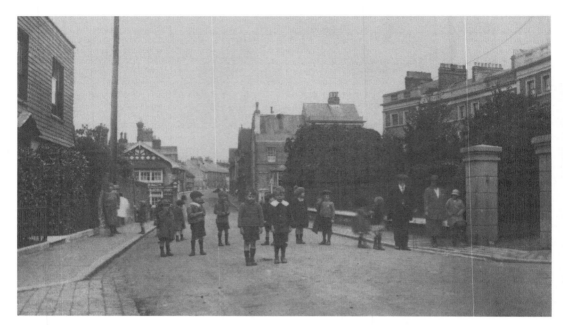

The photographer has lined up dozens of potential customers for the photograph above. It looks back to the King's Head (licensee Emma Goldsmith) from the top of St James Street which had been the major route to the great gateway of the Priory. The King's Head is probably a Tudor inn and its sign certainly bears a likeness to King Henry VIII. Priory Crescent below is a grand terrace built of stucco and buff yellow bricks in the 1840s and 1850s. Nos 6–12 were built first and 3–5 a few years later leading to a change in the brickwork which a keen eye can pick out. Pevsner was harsh, I think, when he described the crescent as 'townish and out of place'.

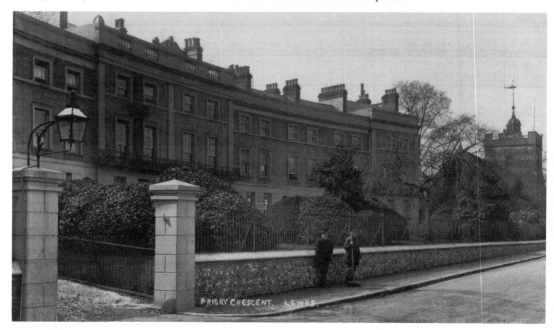

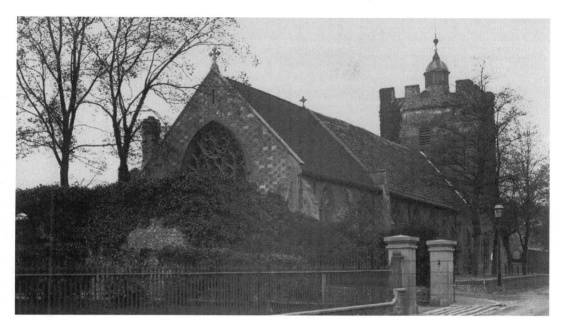

The Church of St John the Baptist dates from the twelfth century and was probably the hospitium of the Priory until the fourteenth. The brick-faced tower is dated 1714 and has the largest weather vane in Lewes. Its 6-feet-6-inches-long basking shark dates from 1738 when the steeple was rebuilt. The fish is an early Christian symbol but the significance of a shark escapes me. It is better seen below in an unusual rear view of the church from Cockshut Road. The carved grave-slab of Gundrada was moved here in 1845 from Isfield after her bones and William de Warenne's were discovered when the railway line was cut through the priory.

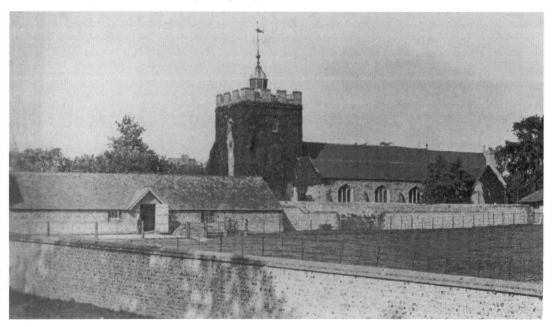

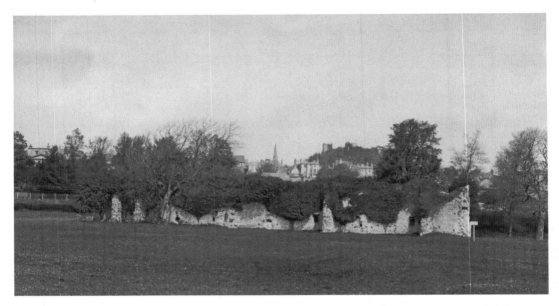

Behind Southover High Street are the ruins of the Lewes Priory of St Pancras. Founded by William and Gundrada de Warenne between 1078 and 1082 it was demolished in November 1537 by the Italian engineer Portinari. Although one of the country's wealthiest religious houses the Priory never had more than twenty-four monks. Its great church, with a 432-foot-long nave, was larger than Chichester Cathedral. The view above looks across to the Castle and spire of St Michael's church. The monk below is not an apparition but somebody dressed accordingly for the Archaeological Society's Country Fair in 1907 (shown on page 123).

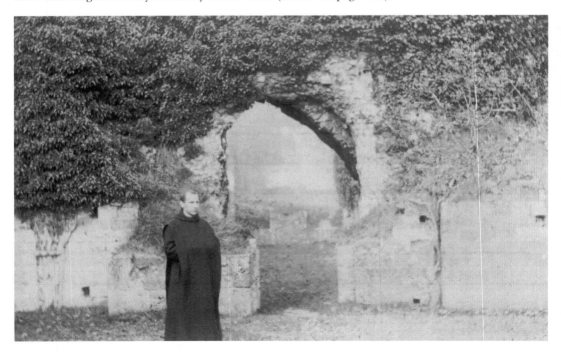

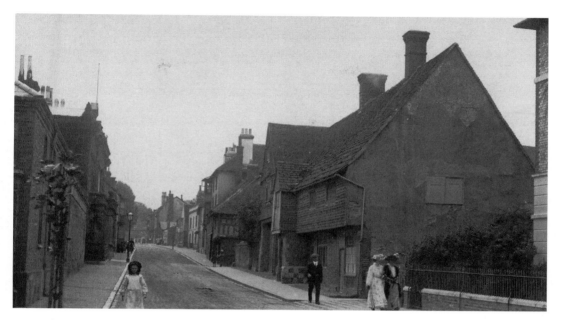

The Porched House now takes its name from Anne of Cleves, Henry VIII's fourth wife, who was given the manor as part of the divorce settlement in 1541. She never lived there or even visited the house but collected the 7s 6d rent until she died. Much of the early sixteenth-century timber-framed building is hidden behind a mixture of local building materials including stone taken from the Priory ruins. It was given to the Sussex Archaeological Society in 1923 by Frank Verrall, its tenements having previously housed a number of poor families.

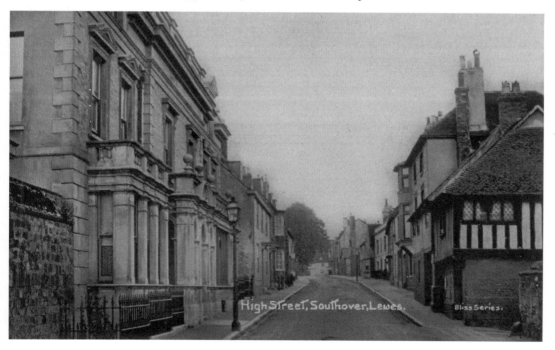

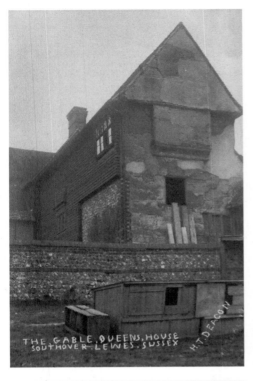

THE GABLE. QUEENS. HOUSE
SOUTHOVER. LEWES. SUSSEX.
H.T. DEACON

The card above shows the gable end of the west wing with repair work being undertaken. While the house is largely an early sixteenth-century rebuild, this is Elizabethan, as is the porch, although two bays are a remodelling of an older wing of the earlier fourteenth-century house. The two-storey porch was added by John Saxpes and has his initials and the date 1599 cut above the arch. Below is Southover Manor House where Frank Verrall, described as of independent means but previously a brewer, lived in 1911 with his wife, two daughters and five servants including a cook.

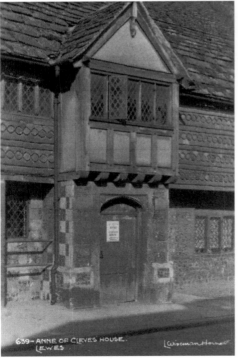

639 - ANNE OF CLEVES HOUSE.
LEWES.
Wiseman House

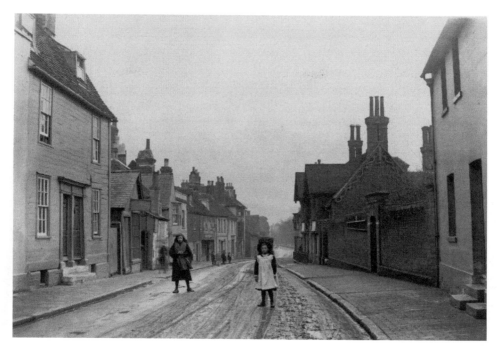

Two young girls stand in the muddy High Street, free of traffic, just before its junction with Bell Lane. This was also once a busy little commercial area but today is free of shops. At No. 40 was Edward Hillman, a wheelwright, Edward Relf a grocer was at No. 45, at No. 52 Harry Deacon, a greengrocer, George Poole was a racehorse trainer at No. 59 and next door to him William Cruttenden a baker. St Pancras Lane led down to another busy working-class area (see page 71) as did Potters Lane below. The fine timbered building on the corner, No. 51, was a seventeenth-century inn called The Three Mariners.

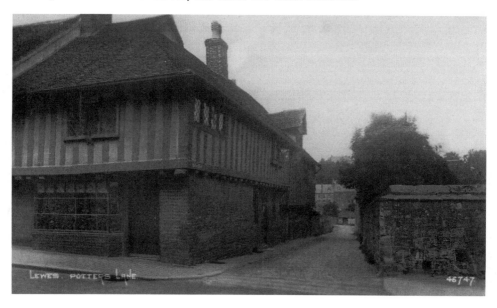

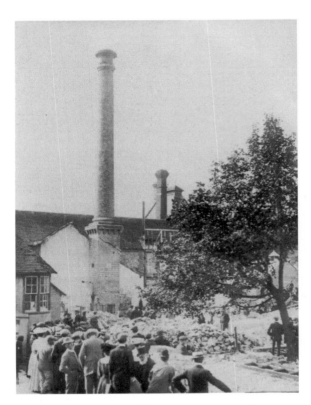
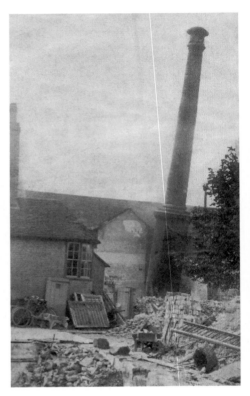

These super cards by Bliss of Lansdowne Place show the demolition of the Verrall's Brewery chimney on 16 September 1906. It stood sixty-five feet high and was brought down by the famous Rochdale steeplejack, Joseph Forest. The buildings had been sold to a Croydon Brewery a few years earlier and used for storage until being demolished for housing. The chimney was left until last and many onlookers stood some way away on the slope between Rotten Row and Winterbourne. At 3.00 p.m., fifteen minutes after lighting the fire, the chimney 'fell with ease and grace ... with very little noise' and left a heap of 300 tons of masonry.

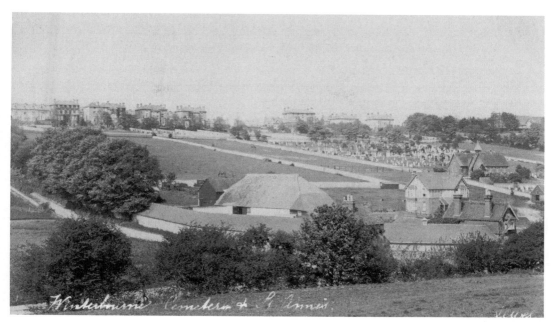

Winterbourne Cemetery & St Anne's.

The Cheetham postcard above shows Winterbourne Farm and Hollow and the municipal cemetery beyond from the present Winterbourne Close. The name comes from the winter-running stream which on a regular basis flooded homes along its route through Southover. The card below shows such an occurrence in 1915 in the area of St Pancras Gardens and The Course (probably the clearest named road in Lewes). As can be seen below, a nondescript dry course for much of the year could quickly change to a dangerous torrent. The stream is now largely contained in a culvert.

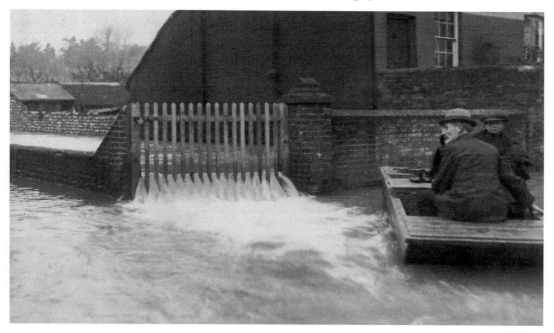

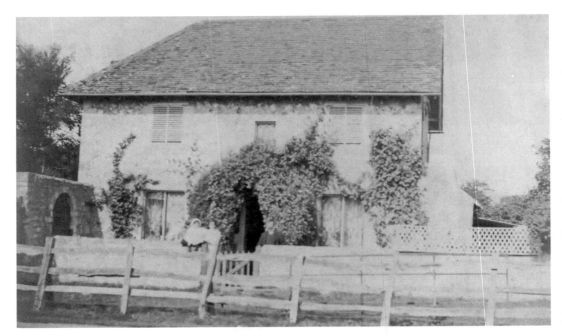

Cockshute Cottage, the little flint house seen above, is down by the Southdown Club. The message on the back, written in October 1907 by T. Taylor, reads, 'This is a photo of our cottage with Miss Kathleen Taylor and ourselves [...] our season finishes this week. Tell Bill all the plants are going on well.' In the 1911 census Trayton Taylor, a groundsman, was living in the cottage with his wife Annie. There is no mention of Kathleen and as I haven't found a death record she must have been a visitor, perhaps a niece. Below, another Cheetham photograph shows Grange Road with the usual crowd of locals getting in on the act. The wall on the left masks the gardens which ran down from Rotten Row.

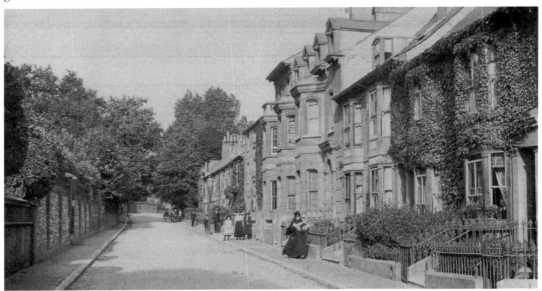

SECTION 8

NEVILL

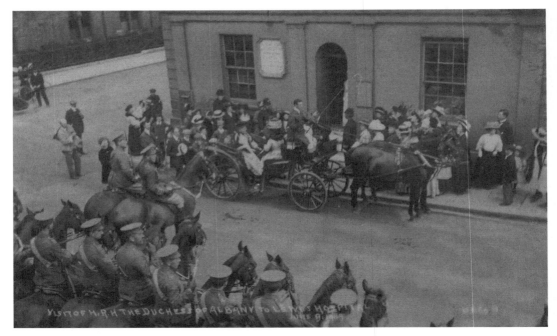

The Victoria Hospital dominates Edwardian Nevill. On 19 June 1909 the Duchess of Albany laid its foundation stone with full masonic ceremony. Earlier she visited the Hospital Infirmary and Dispensary at the foot of School Hill in the building it was to replace. It is now occupied by the Natwest Bank and previously by the Lewes and then Sussex County Building Society. It provided medical advice and medicines to anyone unable to pay who was not receiving poor relief if they, or a sponsor, paid half a guinea a year. It became the Victoria Hospital in 1887 as a Jubilee Memorial after additional rooms were equipped as an infirmary.

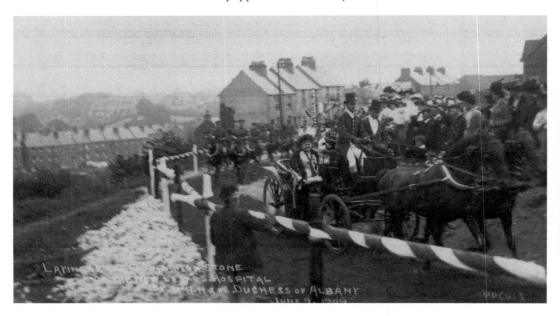

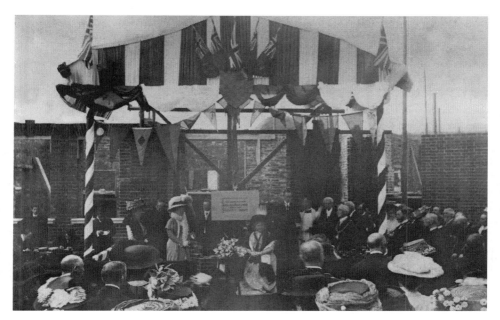

Nine months later on 2 February 1910 the new hospital was born with the opening ceremony performed by HRH Princess Henry of Battenberg. She was presented with a silver key by F. B. Whitfield, a director of Lewes Old Bank. The building costs were £6,170, the land £580 and all furnishings £150. When the hospital opened the directors were still looking to raise the £850 outstanding. The newspapers reported that the accommodation in the wards for the opening ceremony had been very limited and that after HRH left, the hospital was open for public inspection and, 'here and there expressions of delight with the new building were heard'.

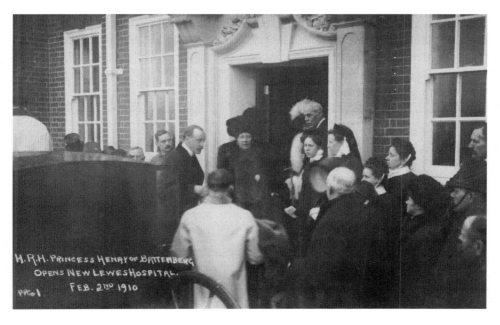

H.R.H. PRINCESS HENRY OF BATTENBERG OPENS NEW LEWES HOSPITAL. FEB. 2ND 1910

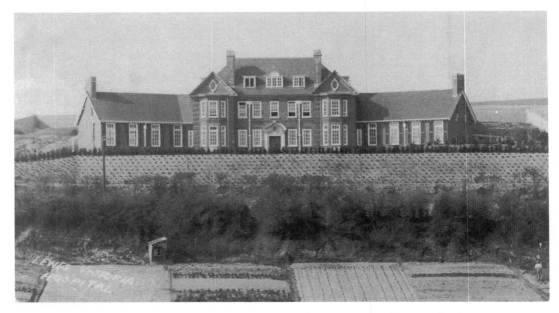

The outstanding money was raised, as were the annual running costs, by annual subscriptions, street collections, carnivals, concerts and sporting events. Some of these are illustrated in Section 14. The first matron was Eleanor Poile. The hospital was basic and the main wards had wooden parquet floors and open coal fires as shown below. In 1924 came the first extension with new casualty and X-ray departments being added. Staff lived in the upper floors which can be seen over the central part of the building in the postcard above. In the foreground are the allotments on which Valence Road now stands.

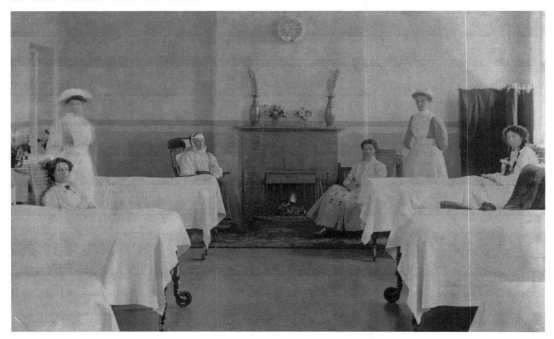

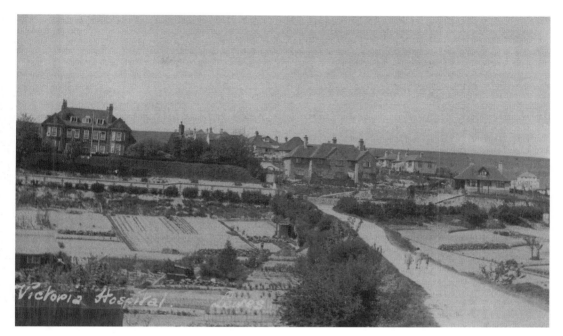

Above, the first houses of the Nevill estate being built give company to the hospital. To the right is the chalky causeway which linked Wallands Farm and the burgeoning Wallands estate to the Offham Road. Most of the Downland Estate was owned by Lord Abergavenny who had a third of the Barony of Lewes and his family name of Nevill was quickly adopted as the development's name. Lord Abergavenny had sold land for the hospital site and the first houses followed soon after. By the early 1920s most of South Way, Middle Way and Nevill Crescent had been built as shown below.

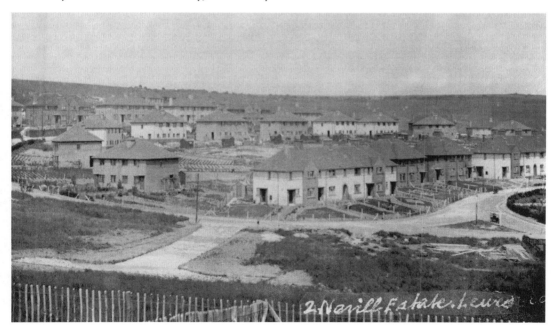

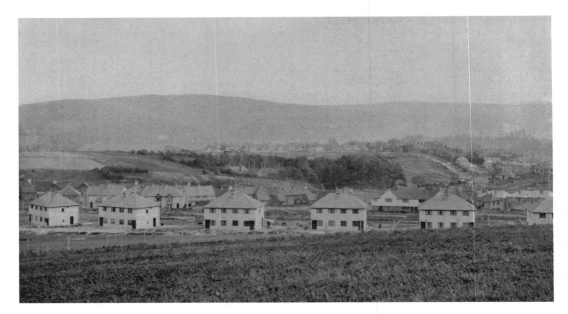

The view above looking down on North Way shows how unusually spacious the plots were for that time. In the 1930s houses were advertised for sale at £495–£675 with deposits of £25–35 or for private renting at 13s to 17s 9d a month. The intended market was tradesmen and white-collar workers at the nearby prison, in the county council, law courts and offices of local businesses. Development continued with Firle Crescent, Mount Harry Road, Highdown et al. being added through to the Second World War including the town's first purpose-built council housing in Middle Way and Cross Way.

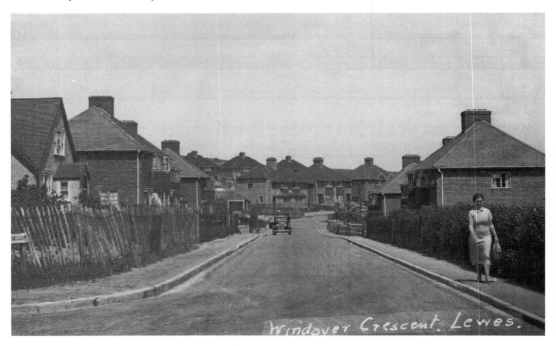

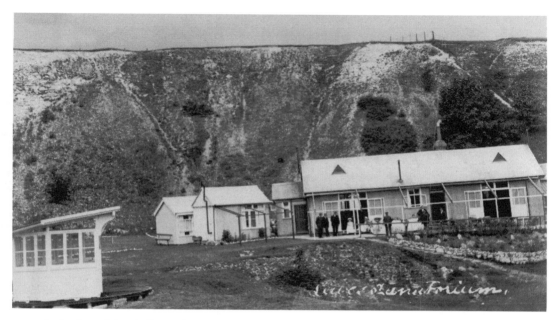

In the first of the chalk pits from Lewes on the Offham Road was the Lewes Sanatorium or correctly the Hospital for Infectious Diseases. It was reached by a lane above the pit which ran off the lower end of the motor road up to the racecourse. It was built in 1876 for £2,000 and provided beds for up to sixteen people and, from the photographs, most likely men only. As can be seen in the postcard below, the perceived best treatment was to give patients as much fresh air as possible. The summer house in the left corner was swung round to catch the sun all day. It is still possible to look down on the site and see the configuration of the buildings including the staff accommodation.

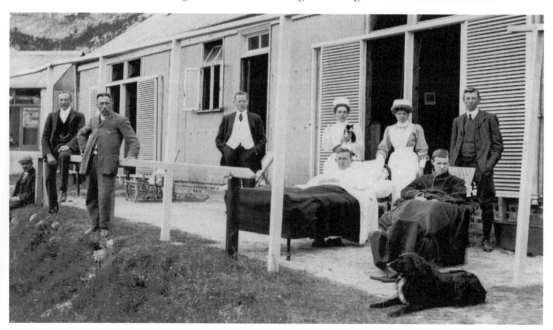

SECTION 9

ELSEWHERE

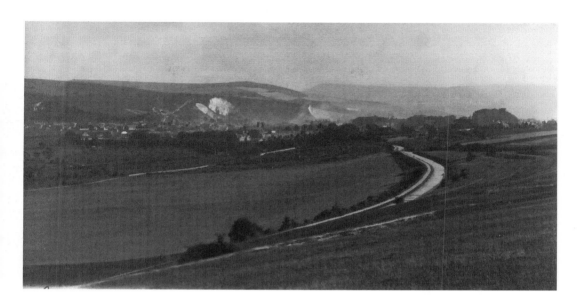

Douglas Miller's postcard shows an open view down to the river from the Downs. The Offham Road cuts through the centre and below it are the allotments by Landport Lane and the fields of Landport Farm. It was here that the Borough Council built hundreds of houses in the 1930s so to rehouse those displaced by their slum-clearance programmes and particularly in the North Street area. Below is a view of lower Station Street to its junction with Lansdowne Place. The New Station Inn, built in 1857 and demolished in 1963, is on the bottom left. The projecting building was demolished to allow redevelopment of the Central School.

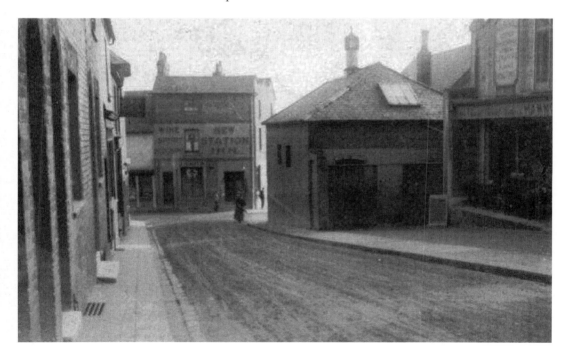

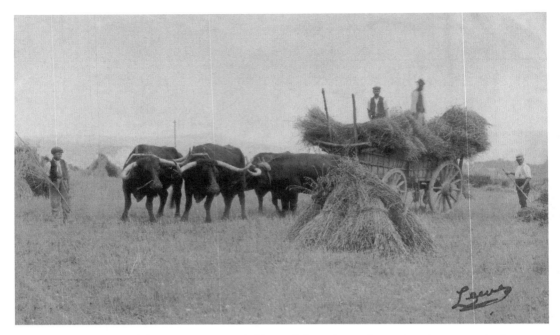

The area to the north of the town was open fields until the 1870s. Information given to me by Joy Preston gleaned from local directories shows that by 1873 there were houses in Prince Edward Road with the first house, The Limes, owned by John Every, in North Corner. Wallands Crescent and King Henry's Road appear in the 1890s. D'Albiac Avenue and Bradford Road were built from 1905 and W. E. Baxter sold the last of his Wallands land at the White Hart Hotel in spring 1907. D'Albiacs had owned the Paddock Estate but lost their final association with it in 1908 when, at the request of the residents, their name was removed from The Avenue.

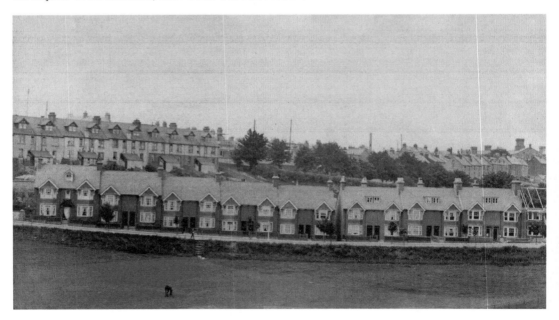

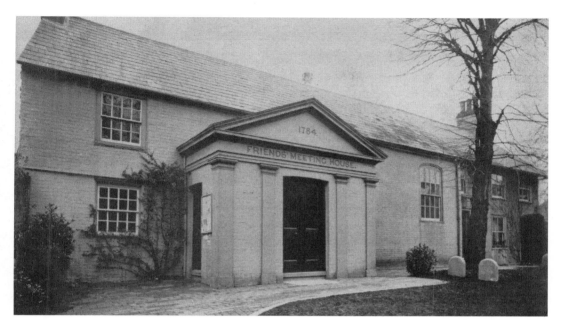

Above is the beautiful Friends Meeting House in Friars Walk which bears the date 1784 although the Quakers were in Lewes some 130 years earlier. Earlier meetings were held in private houses followed by the first meeting house in Foundry Lane on a site later occupied by the gasworks. The Friars Walk site had been a burial ground before the Meeting House was built with a front of mathematical tiles over a wooden framework for £229. Below is the equally pleasing All Saints Church, although this is a Victorian rebuilding of a fourteenth-century church. It is now a highly valued community centre and, except for the missing pews, still has the fine Victorian interior and organ.

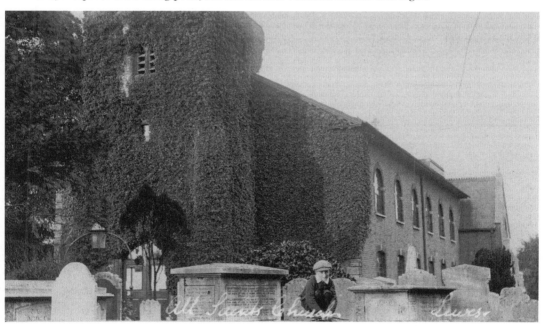

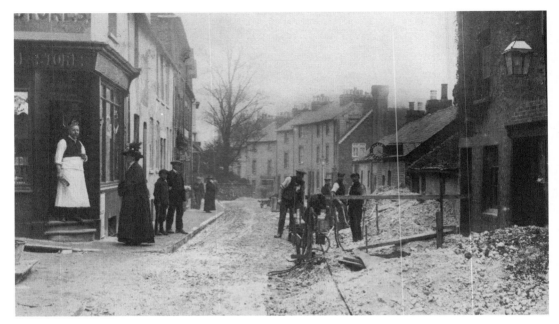

Both cards on this page are of Lansdowne Place, above, looking back to Friars Walk, and below, towards Station Street and the Central School. Digging up roads is an ancient Lewes tradition and here, at the bottom of St Nicholas Lane, electricity cables are being laid in 1905. The general store was owned by William Tribe, who is standing in the doorway of what is now Vrac, the tea house and emporium (*vrac* being French for 'loose', representing how they sell tea). Many in the terrace of townhouses beyond offered rooms to let, bed and breakfast and dining rooms, given the close proximity of the railway station.

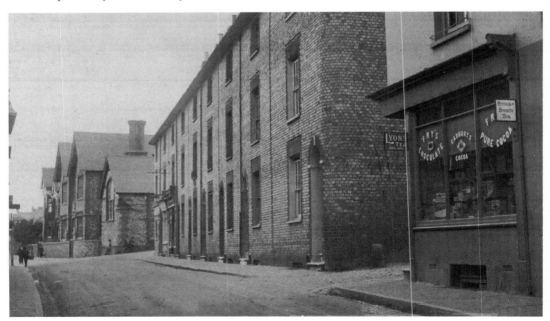

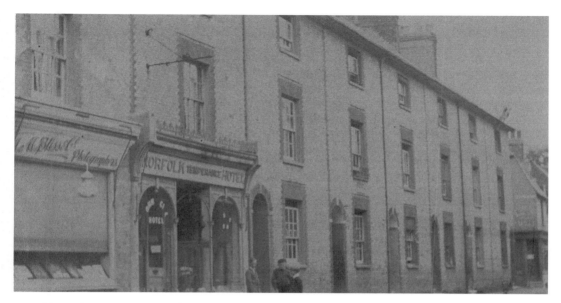

Towards Station Street is the Norfolk Temperance Hotel, now the Symposium wine shop, and next door is the County Studio, the premises of Bliss & Co. and currently Erawan the Thai restaurant. A popular producer of Lewes postcards, Bliss offered seven cards for 6d. Both cards on this page are by Cheetham, who, along with Edward Reeves & Son and Bliss, were the great triumvirate of Lewes postcard producers before the First World War and about whom I wrote in the introduction to my book, *Lewes Through Time*. The Central School, whose headmaster at the time was Mr Hodges, opened in 1840 and after closing in 1938 became a doctor's surgery.

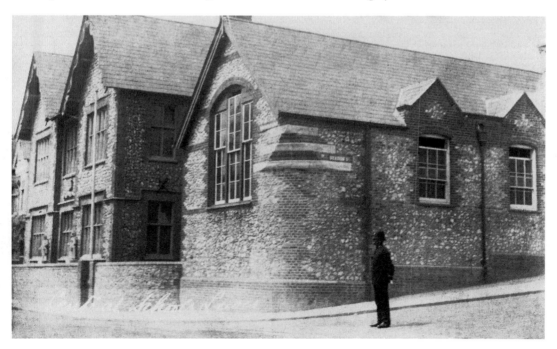

Above is the White Lion Inn in Westgate Street showing Mrs Fuller, the licensee. It was demolished in 1937 as part of a slum-clearance scheme and has been a car park ever since. The inn sign was rescued by the Friends of Lewes and, refurbished, is grandly displayed in the Town Hall. Westgate Street was originally known as Cutlers Bars, then Westgate Street and White Lion Lane after the pub. Below is a view of Eastgate Street, recognisable now only by the Baptist Church on the left which was built in 1818 and rebuilt in 1843. Its Sunday School, opposite, opened in 1899 and was demolished in 1967 when the Phoenix Causeway was built.

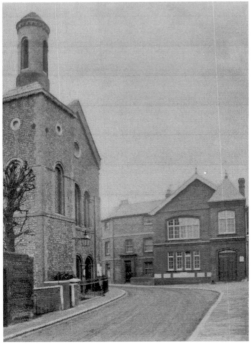

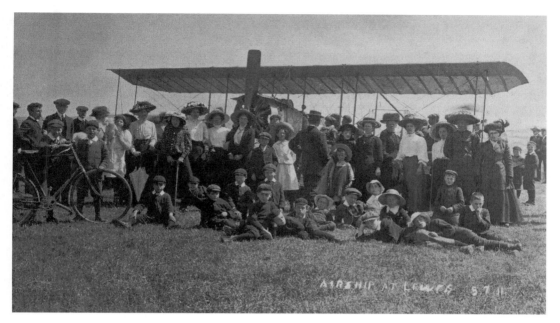

Two very different forms of transport appear on this page. Above is the then-modern Caudron biplane of Duval which landed at Rye's Farm during the Great European Air Race in July 1911. The route was from Paris to London (Hendon) via Dover and Shoreham Airport. First prize was £2,500 and had eleven competitors, just two years after Louis Blériot had made the first Channel crossing. Below, *Gladys* of Harwich is seen loading at Every's wharf and is typical of the vessels which had plied the River Ouse for hundreds of years and, to give an example, harbour tax on 6,000 tons was paid in 1905. Barges brought in raw materials and took out the finished iron products.

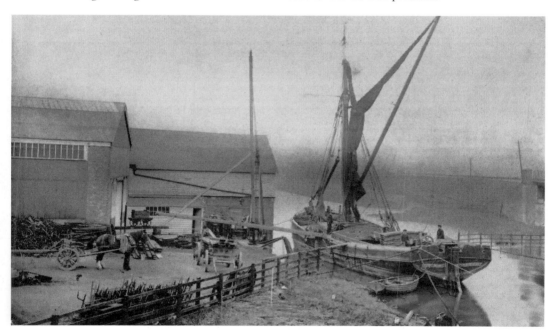

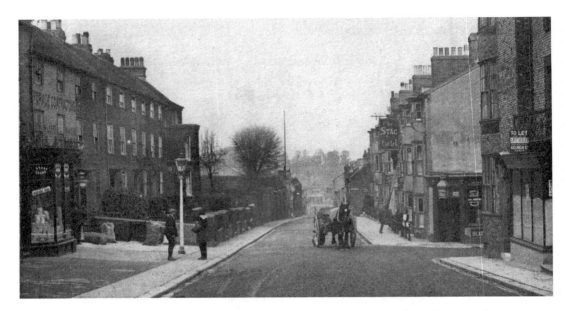

Along with Malling Street, North Street has seen the greatest change since these photographs were taken. The terrace of houses on the left in the top card was destroyed in 1943 and the telephone exchange now occupies the site. Opposite, and at the top of East Street, was the Stag Hotel. It was obliterated by a direct hit from the Luftwaffe on 20 January 1943 and two people inside were killed. The houses below it were destroyed at the same time and later that evening, following an explosion of the burst gas main, the houses across the road also went. The site has been a car park ever since.

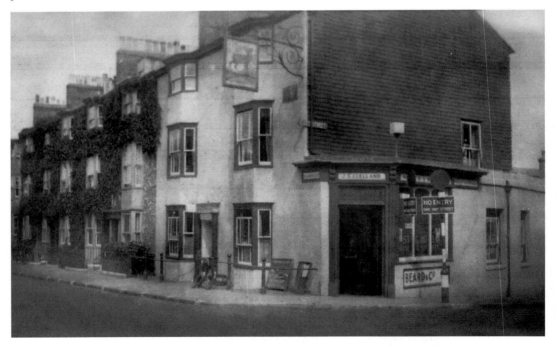

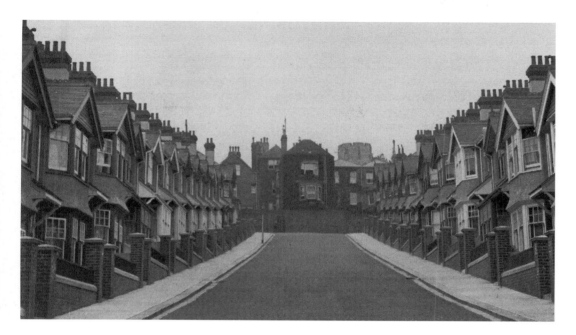

St Swithun's Terrace, above, is named after the ninth-century Bishop of Chichester. The houses were built in 1907 by the Brighton builder William Marchant on gardens adjoining the lost twitten from Stewards Inn Lane. Leicester Road, below, is one of two roads named after the Earl of Leicester, who was victorious at the Battle of Lewes in 1264, the other being De Montfort Road. This road is typical of the working-class housing which developed from the late Victorian period. It was popular with prison officers who occupied eight of the houses in 1911 and those whose work depended on the numerous racing stables in the area.

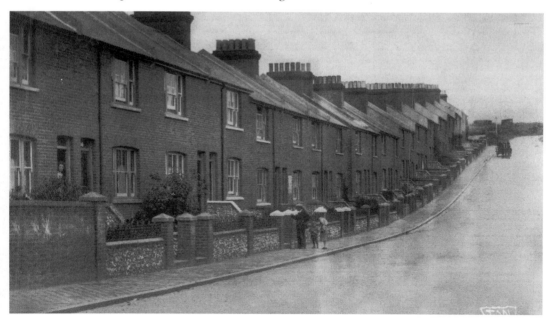

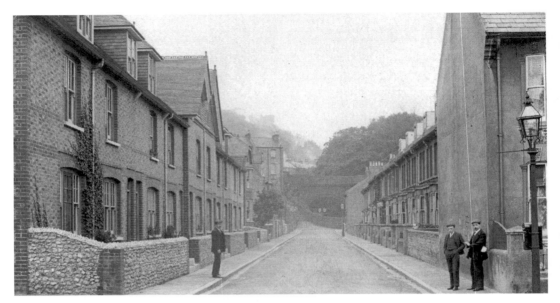

The Pells area is little changed and the postcards of Talbot Terrace and St John's Hill could almost have been taken today, though there may not be the same level of curiosity as then and motorcars and the ubiquitous yellow lines would now spoil the pictures. Talbot Terrace and adjacent streets were built on the old cattle market site. It is probably named after the family name of the Earls of Shrewsbury although it is a tenuous link. St John's Terrace was built a year later in 1884 and the area was an early development outside the medieval boundaries of Lewes.

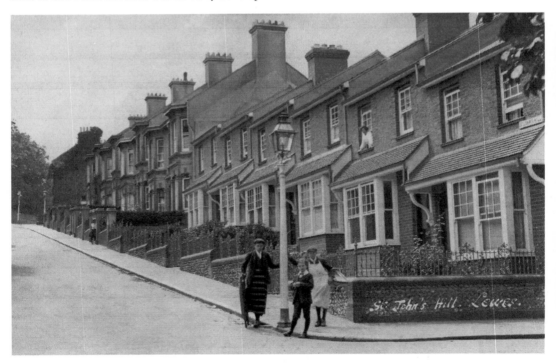

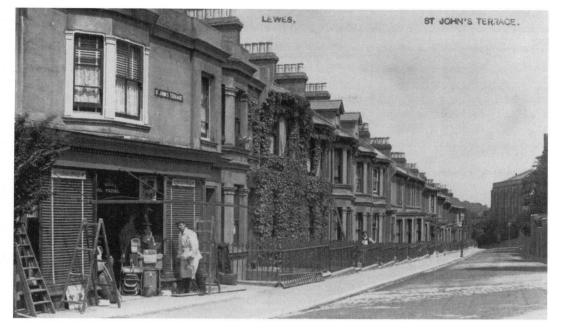

St. John's Terrace runs from White Hill beside St John Sub-Castro Church, and down to the Pells. The shop at No. 2 in the foreground was a saddler's business run by Esther Young, although by 1914 it had become a confectioner's shop. White Hill was previously known as White Chalk Hill which described the steep narrow lane which formerly crossed the Paddock Valley. In 1821 the Offham Turnpike Trustees lowered the hill on either side and filled up the valley with the material to make a causeway. Before the cut the only route had been out via Nevill Road. The Elephant and Castle was built in 1838 to pick up the passing business.

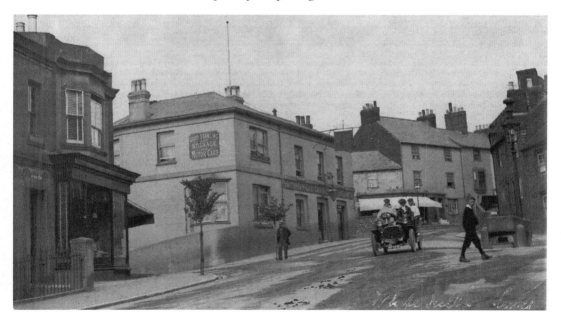

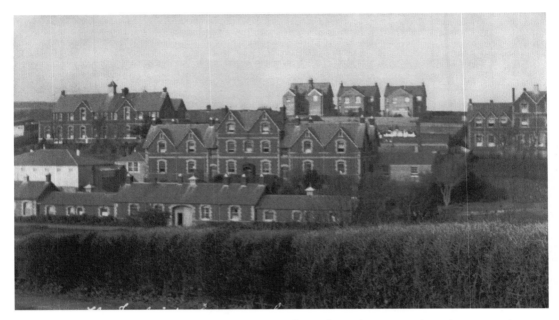

Used subsequently as a home for inebriate women, barracks and an army detention centre in the First World War, the workhouse was built in 1868. It housed 205 inmates and the males and females, including married couples, lived separately, only coming together for social occasions, which were not frequent. The De Montford flats replaced it in 1960. The Pells below is derived from the old English 'pol' meaning a deep pool. A series of ponds supporting the paper mill business of George Molineux were made into a large ornamental feature when the land was developed as a pleasure ground, along with the Pells swimming pool, in the 1860s.

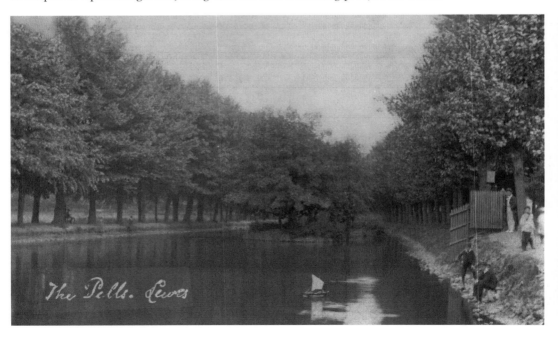

The Pells. Lewes

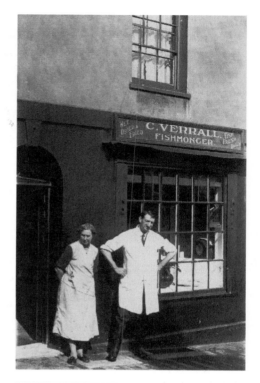

Charlie Verrall had his popular fishmonger's business at No. 12 North Street and is pictured standing outside the premises with his wife. The cottage is one of the few to survive and is between Lancaster Street and Gorringe's Auction House. It typified the many small traders who made the area so vibrant until the 1930s. Other postcards of the street are shown on page 88. Below is a close-up of the Prison Windmill (shown on page 59). It was formerly the town mill, having been opened to mill barley and wheat in 1802, an opening celebrated with a grand ball. It was moved to the prison site in 1819 by William Smart and its fan and sweeps were removed in August 1912.

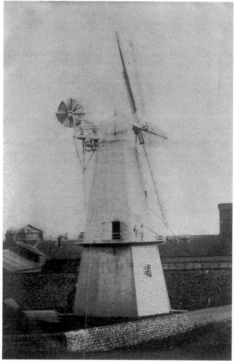

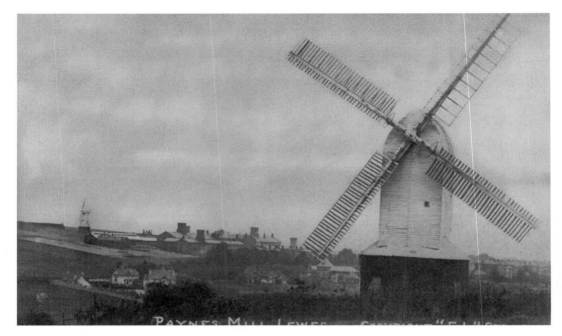

Windmills surrounded Lewes until 120 years ago. Above is Payne's Mill which stood along Juggs Lane. The fine shot shows the prison windmill on the distant skyline and with little development in between. The mill first appears on Bugden's map of 1723. It deteriorated from 1901 and was pulled down by ropes in August 1913 by Messrs Wells of Lewes. Ashcombe Mill, below, was rare because of its six sweeps and was the last surviving Lewes mill when it was demolished following storm damage on 28 March 1916. It first appeared on maps in 1823 and James Tasker has almost finished building a replica on the original site just off of Juggs Lane.

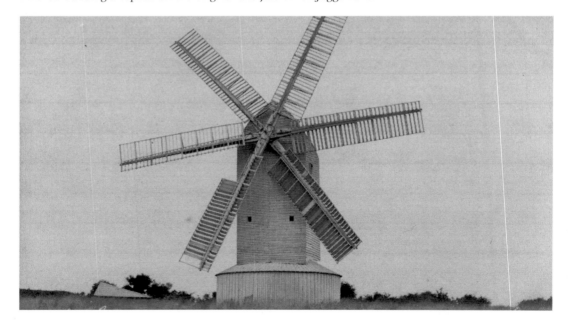

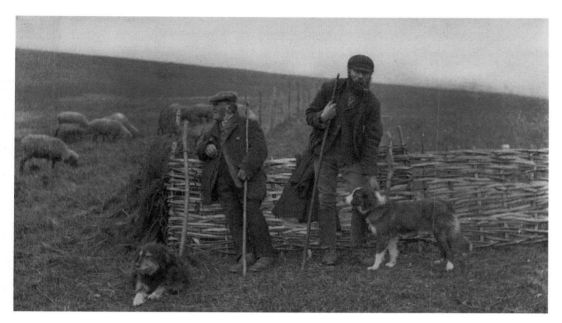

Lewes was also surrounded by farms with a number such as Wallands, Houndean, Nevill, Landport and Malling being developed for housing from the 1870s through to the present time. The cards here evoke memories of the times when farming was labour intensive and before the use of horses and large-scale machinery or tractors. The shepherds above worked in the Ashcombe/ Kingston Ridge area and would have lived out with their sheep for most of the year. The team of eight oxen, below, worked on Houndean Farm and suggest how tough it was to plough on the downs although the Sussex black oxen used were placid and hard working.

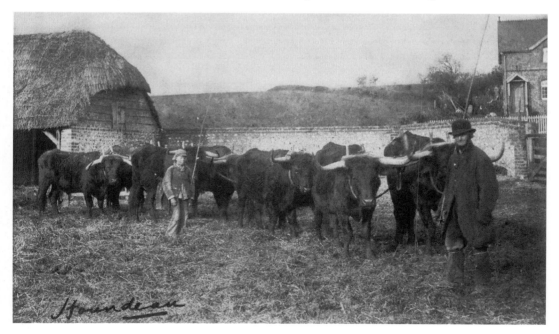

SECTION 10

WAR AND PEACE

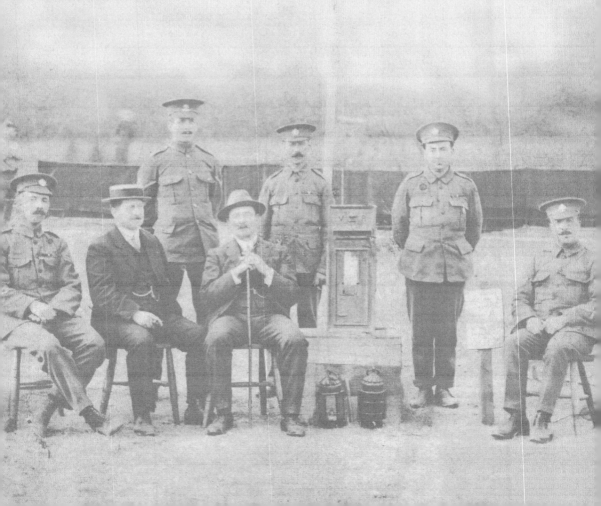

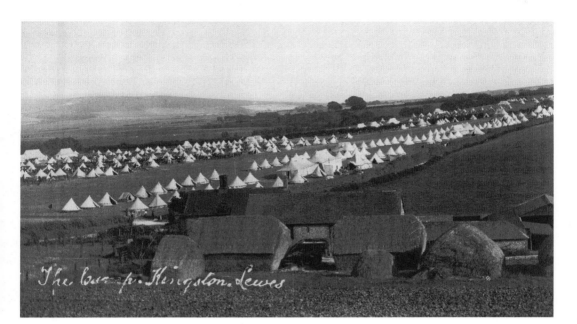

The camp. Kingston. Lewes

Lewes was a popular location for Territorial Army camps from London and the south-east. After initial training Territorials had to attend an annual two week camp. Spring Barn Farm on the Newhaven Road was often used and also hosted Kitchener's Army in the First World War. Houndean, Malling, Horndean, Ashcombe, Southerham and Hope-in-the-Valley (see below) were also popular. The impact on the town when several thousand soldiers arrived must have been immense. In 1910, for example, between 26 July and 6 August, fifty-six officers and hundreds of men of the Home Counties Divisional Telegraph Company and four battalions, each of 700 men, from the Surrey Brigade were in the fields of Houndean close to the prison.

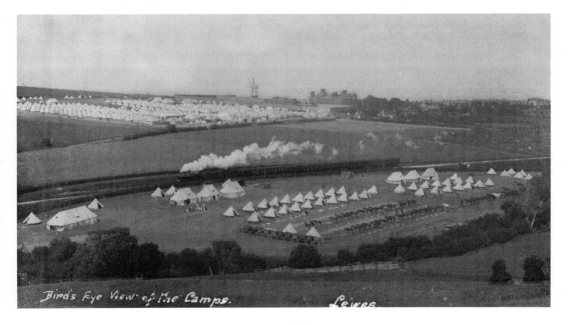

Bird's Eye View of the Camps. Lewes

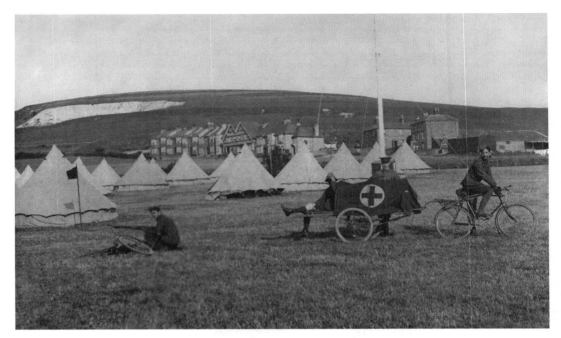

Another small company of the Surrey Brigade and 150 men of the Headquarters Company of the Home Counties Divisional Transport and Supply Column (ASC) were posted during the same fortnight in nearby Hope-in-the-Valley. On the previous page both can be seen in the bottom card. The bypass now runs through the lower camp site. Further west, shown below, twenty-two officers and 420 of the West Kent Queen's Own Yeomanry were based at Horndean. At South Malling where Queen's Road was built, a small contingent of the London Cyclists Brigade even had their own ambulance. I wonder how fast they could cycle with the blue light flashing?

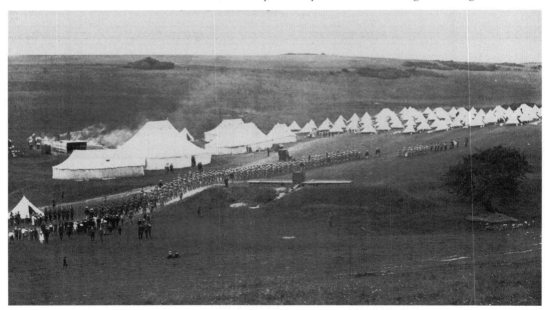

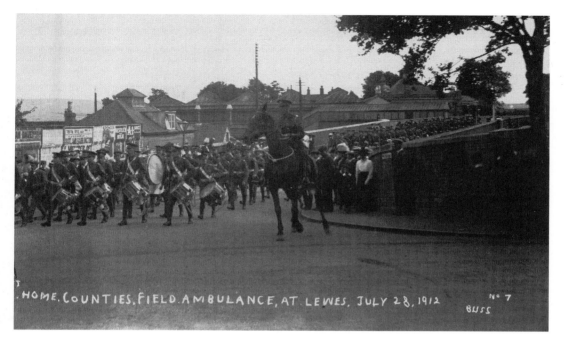

.HOME.COUNTIES.FIELD.AMBULANCE, AT LEWES, JULY 28, 1912 N° 7 BUSS

The Territorials arrived in town by various means. Most popular was the train as exampled above by the Home Counties Ambulance Brigade in 1912, led by their regimental band. They are about to turn left into Lansdowne Place and on to their camp at Malling. Their horses, weapons and many supplies were also brought by train. Others marched from their home bases and below an unknown group can be seen approaching the camp at Horndean. I often wonder how many of the young boys of the town were attracted to imitate them and either volunteered or were conscripted a few years later. You can guess how the cyclists travelled.

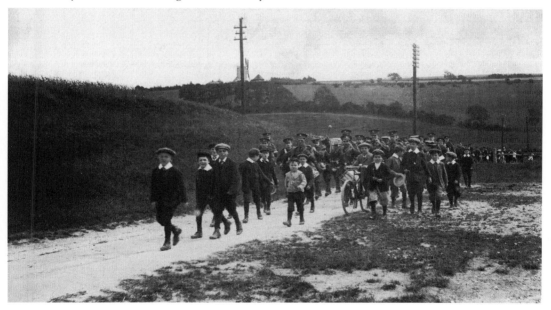

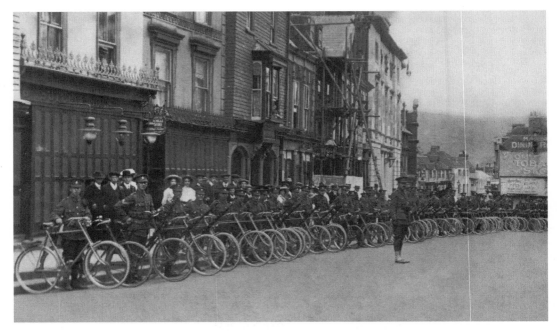

For most of their fortnight's stay in Lewes the men were restricted to camp but there were occasional incursions into town. The Cyclists Brigade shown above is presenting arms (on crossbars!) outside the Law Courts, while below the Royal North Kent Mounted Rifles can be seen marching past the Black Horse in Western Road on their way to church from their Houndean camp. As always, the crowds gathered to watch them. The card was posted by a young man who was operating a refreshment stall in the Recreation tent described on the next page. He says, 'It is quite a holiday for me and am enjoying it immensely. I am doing fairly well considering it is such a small camp (500).'

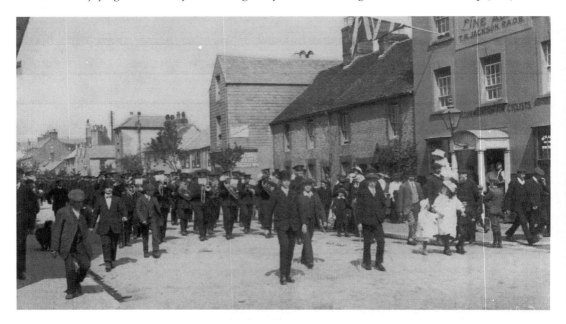

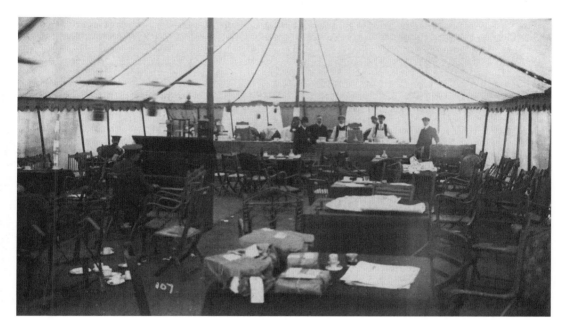

The Recreation tent at Kingston Camp in 1910 had a large bar and, in the foreground, can be seen parcels processed by the camp's own post office (shown on page 96). The Territorials brought many of their own supplies but local businesses also benefitted, shown below, by Harvey's delivery wagon unloading. Having food processed and cooked on site on a large scale was not without problems. The message on the card reads, 'A Company have been moved across the field as they have got food poisoning. We have all paraded before the C.O. to say what we had to eat yesterday.' A post script was added, 'It was the roast beef that caused the trouble. I did not have any. I had stew.'

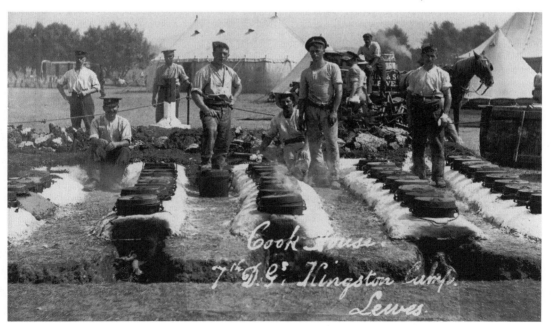

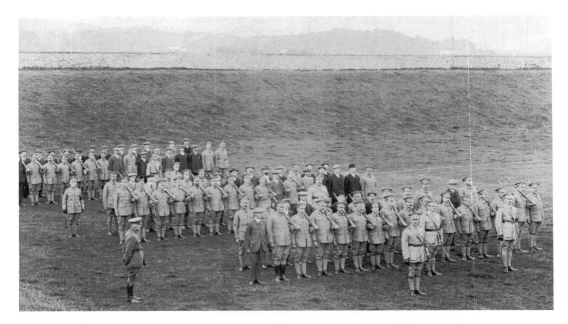

With a relatively small standing army when the First World War started in 1914, there was an urgent need to mobilise the Territorials and sign up volunteers. The card above shows some of the early Lewes and district recruits who helped form new battalions of the Royal Sussex Regiment seen here parading at the Dripping Pan. Below, the mayor of Lewes, T. G. Roberts (see page 58) is seen kneeling and shooting on the rifle range which was situated in the Bible Bottom/Cliffe Hill area. The photograph was taken later during the war as standing behind him in uniform is the Borough Surveyor David Roberts.

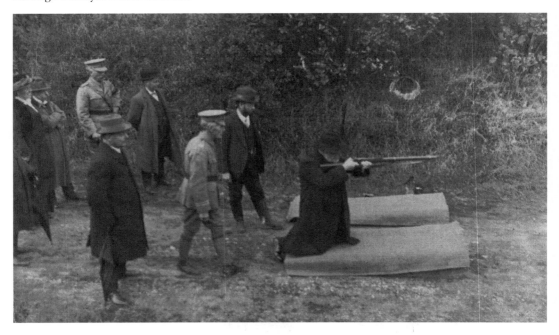

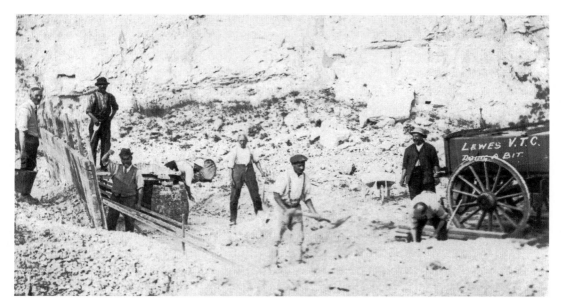

As would be in the case in the Second World War, steps were quickly taken at the outset of the First World War to make use of men who were under or over military age or in reserved occupations. In November 1914 the Central Association of Volunteer Training Corps was established by the War Office. Initially, without uniforms, equipment or arms, the Corps was supported by their local TAs. They were trained in drill halls to undertake a wide range of duties including guarding vulnerable points, digging anti-invasion defences, assisting with harvesting, fire fighting and providing transport for wounded soldiers. In these photograps the Lewes Volunteer Corps is undertaking unknown duties, probably at Southerham Grey Pit, in August 1915.

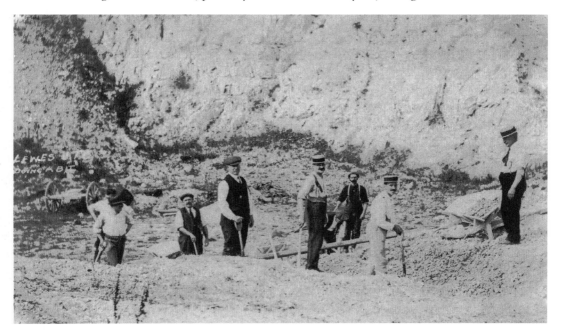

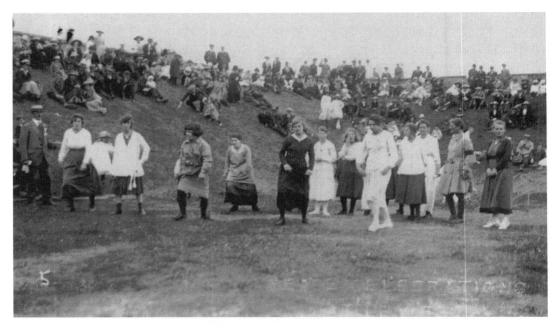

Wounded soldiers returned to England to recover and local houses were commandeered for use as makeshift convalescence homes. School Hill House (seen on page 38) was one of these. The war finished in November 1918 and in the following July Lewes held its Peace Celebrations at the Dripping Pan. A Service of Remembrance was followed by a variety of games and athletics events. These cards show the start of the women's sprint and the men putting on women's clothes in the Aunt Sally event. It is rare in all the cards I have of these celebrations to see a man still in uniform.

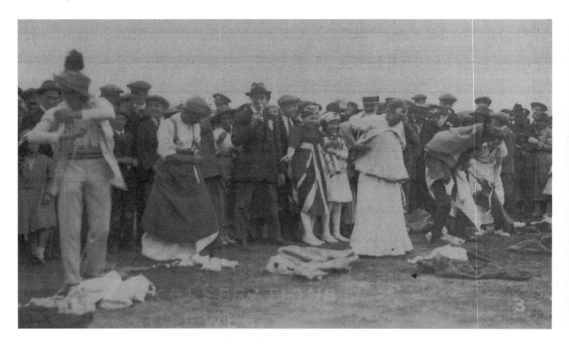

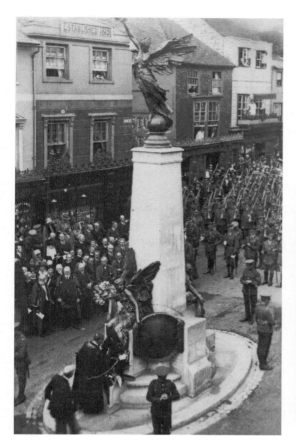

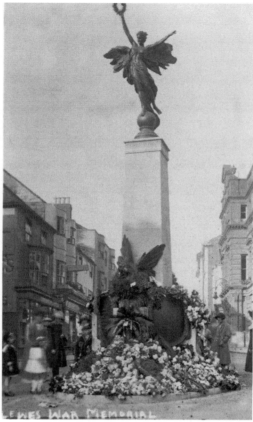

Towns and villages set out to have permanent reminders of their war dead and Lewes decided to have a cenotaph at the top of School Hill replacing an ornate lamp standard (see page 38). Raised by public subscription, it was unveiled on 6 September 1922 by General Sir Henry Sclator. The Bishop of Lewes conducted the service from a raised dais which also accommodated the dignitaries. Four detachments of local soldiers, fifty members of the British Legion and numerous scouts and guides formed the honour guard. The memorial stands 26 feet and 6 inches high and has a Portland stone pedestal surmounted with a bronze figure of Victory with outstretched arms.

SECTION 11

BONFIRE

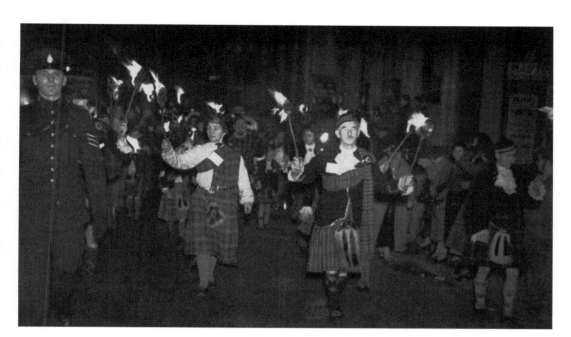

The first bonfire celebration in Lewes was recorded in 1679, although all citizens were required by law from 1606 to hold a thanksgiving each year on 5 November. The card above shows the Borough Bonfire Society parading down School Hill in the United Grand Procession in the mid-1920s. It was given to me by Norman Oliver whose grandfather, Christopher Oliver Snr, is in the Scot's dress accompanied by his daughter, Francis Geer. The five societies each had their own bonfire site on the town fringes and Cliffe's was on Chapel Hill adjacent to the Martyr's Memorial (see page 17) and below the eighteenth fairway on the golf course.

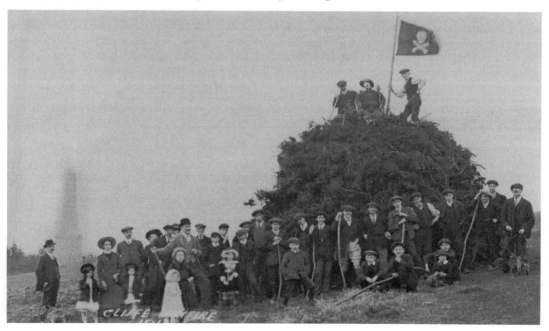

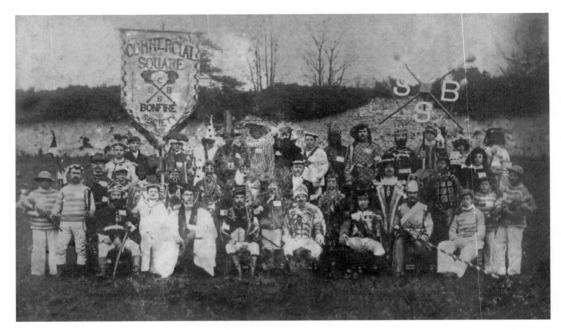

Each society has its own territory and organises its own celebrations, coming together (although not Cliffe in recent years) only for the Grand United Procession. Each has its own colour combination, hooped Guernseys and pioneer costumes which were fairly simple a hundred years ago as demonstrated above by members of the Commercial Square in 1908. Note the banner showing their emblem of crossed torches and the absence of women. The Cliffe tableaux of John Bull can be seen on page 106 and below the South Street creation for 1927 'Needed – Courage or Bravery'. This depicts Charles Lindburgh's first flight across the Atlantic in *The Spirit of St. Louis*.

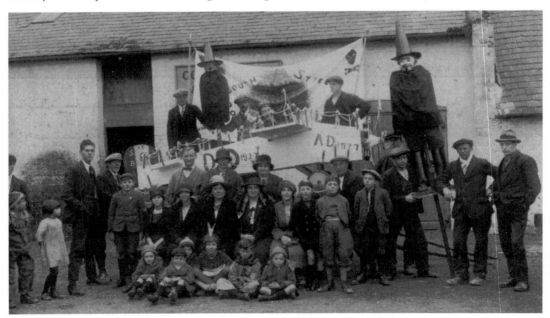

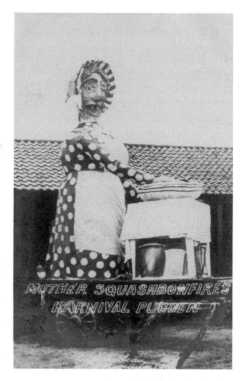

Most eagerly anticipated at today's celebrations are the tableaux depicting the enemies of bonfire. The card above shows a response to those objecting to bonfire in 1912. Its message reads, 'I saw this beautiful figure in Mr. Moorey's shop. It was almost a living tableaux as some man was inside her making her move her right arm, turn her head and wink her eyes.' Below is featured a Lewes Bonfire legend, Thomas Wheeler, who lived at No. 31 South Street. He was a stalwart of Cliffe but in 1913 was instrumental in establishing South Street Bonfire Society as a Juvenile Society to give children an opportunity to join in the celebrations.

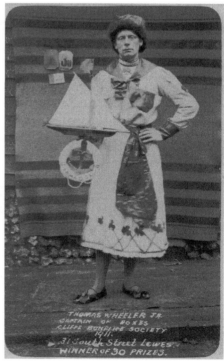

SECTION 12

FIRES AND FIREFIGHTERS

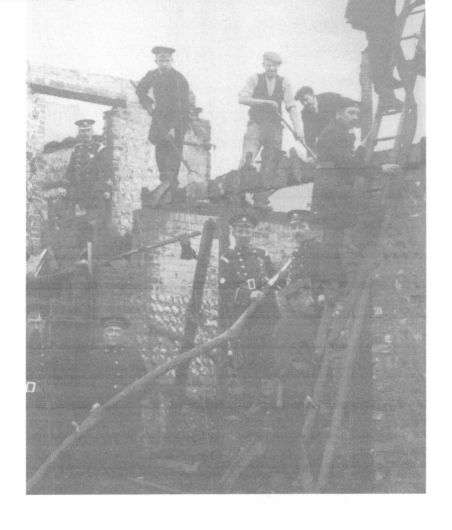

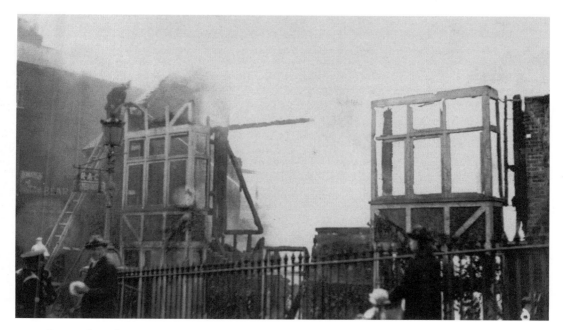

Featured on the previous page, the Soap Factory Lane fire on 9 September 1912 was one of many major Lewes fires between 1900 and 1920. The buildings, owned by Elphick & Son and G. B. Kent, were totally destroyed, having contained hay and straw and the large marquee, tables and trestles belonging to the Lewes Poultry Club. The fire engine had been delayed for twenty minutes as the horses needed to pull it were being used elsewhere in town. The Bear Hotel (see page 25) burnt down in 1918. The substantial timber-framed building and its stables behind in Bear Lane were quickly destroyed by an intense fire. As the postcards show, there was little regard for health and safety.

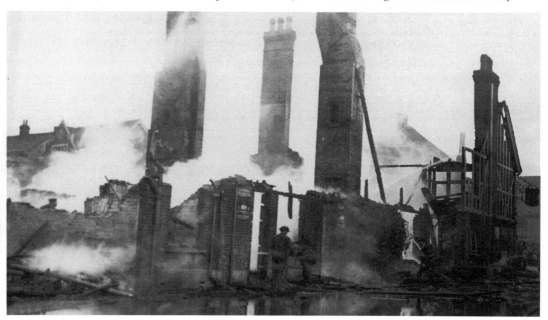

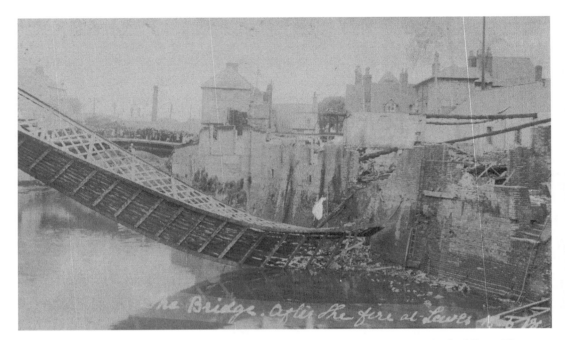

In spite of a quick response from the fire brigade, little could be done to save the buildings. The devastation is shown above and the intense heat melted the metal fittings holding up the footbridge that crossed to warehouses on the other side of the river. A huge crowd watched from Cliffe Bridge. The fire tug *Haulier* was called from Newhaven to help fight the fire from the river. This excellent action shot hides the truth however as the tide was out and the tug was stuck for hours on mud near the rowing club. It made a grand appearance after the fire had been put out, but was only used for damping down.

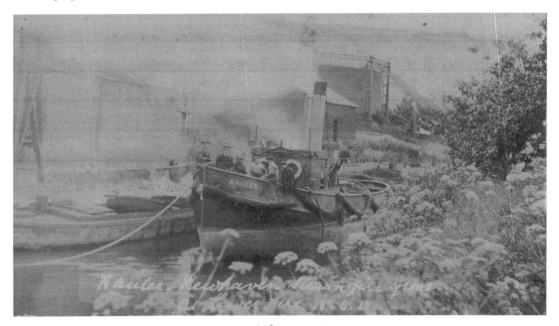

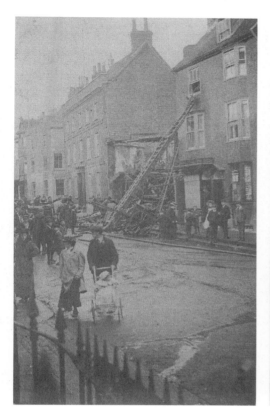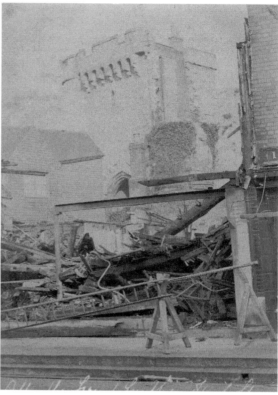

Only swift action in dealing with the Smith's fire on 19 October 1907 prevented major destruction of the upper High Street and the loss of life. A passing policeman, DS. Adams was patrolling at the rear of the property in Castle Ditch Lane at 2.30 a.m. when he noticed the fire well alight. He put up a ladder and rescued Mr Smith, the owner. He then ran to the Fire Station at the back of the Crown Hotel and returned with a hose car. The steamer arrived soon after and for one and a half hours successful efforts were made to stop the fire spreading to Barbican House on the west side and the shop of the Mses Blaber & Young on the other.

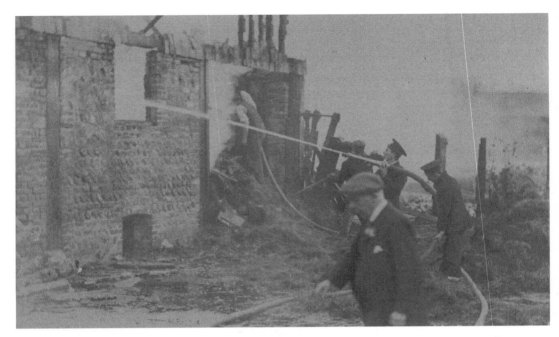

The top postcard shows another action shot of the Soap Factory Lane fire. This was a busy commercial and residential lane which ran down to the river from Malling Street. It now lies under the Phoenix Causeway. The fire below was at the Presbyterian Manse in Grange Road also in September 1912 and happened at 3.00 a.m. The Revd Granville Ramage was woken by three loud explosions to find the house engulfed in smoke. He crashed through a back window, slid down the drainpipe and put up a ladder for his daughter and two sons to escape. The steamer arrived quickly but as the fire had a strong hold it took until 6.30 a.m. to extinguish.

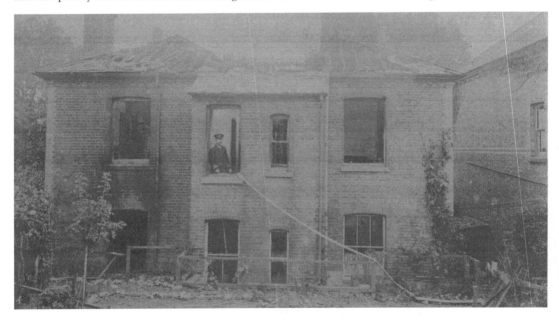

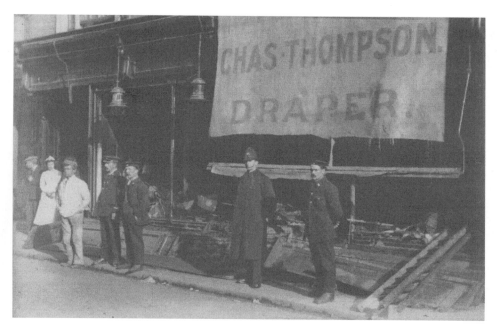

Cliffe was another hazardous place and the fire above at Thompson's drapery on 23 April 1911 followed an earlier one on 28 February. The first was dealt with quickly and without major damage following the swift action of a patrolling policeman, and luckily Edward Fuller, the lamplighter, spotted the second and with the help of two policemen rescued the twelve occupants living above the shop. Below is the fire brigade outside its newly erected station at the bottom of North Street in March 1907. The full costs of building and equipping it were covered by a loan of £1,150 spread over thirty years. A motorised steamer was deemed to be too expensive.

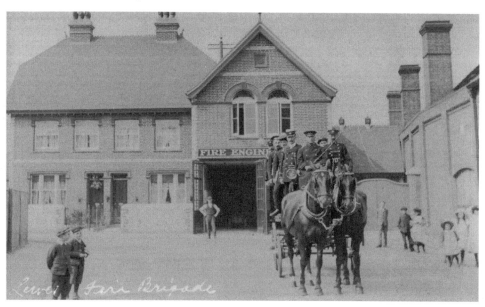

SECTION 13

STREET PARADES

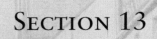

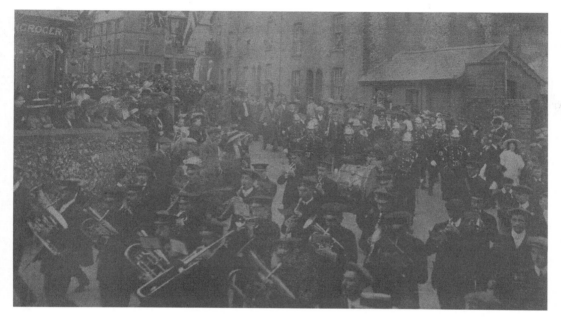

As well as for Bonfire, Lewes people needed little reason for a street parade. On this page are celebrations for the 1911 Coronation of George V. Above, the parade is turning in to Abinger Place for a service at St John Sub-Castro Church. Below, the children are making their way down Mountfield Road to enjoy sports and tea and to receive a coronation cup each at the Convent Fields. They are passing by the modern-day car park beside the Dripping Pan. Unfortunately 22 June was largely wet and miserable but the 2,000 children attending still enjoyed a tea provided by local traders. In the evening a beacon fire was lit on Race Hill following a torchlight procession from the prison.

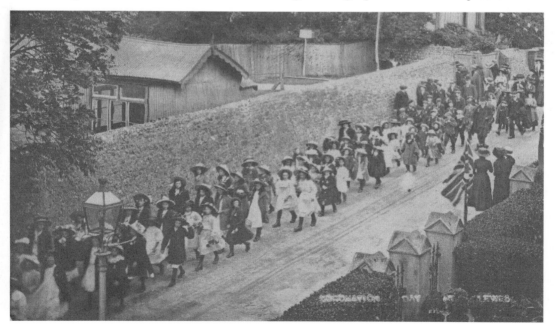

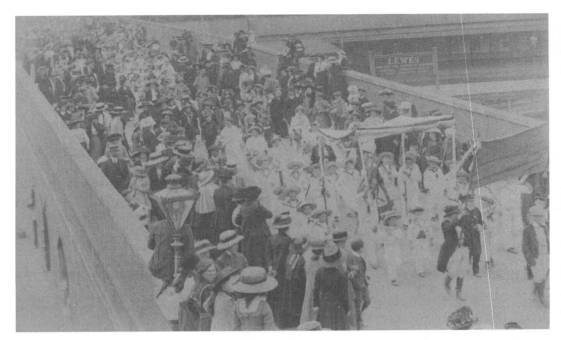

On Empire Day in 1911 children were given the afternoon off as a holiday by the mayor after he had visited each school in the morning. 1,500 children marched again to the Convent Field for sports and tea. Above, the parade, led by John Bull carrying the Union Jack, is crossing the railway bridge. Close behind are boys in sailor suits, scouts and girls in country dresses. Below, the girls take centre stage as they return along Lansdowne Place and are passing the buildings now occupied by Laporte's café to the right (another of my favourite haunts) and the Union Music Store on the left. The latter was occupied by 'Banana' Bill Penfold when I worked in Walwers Lane in the 1960s.

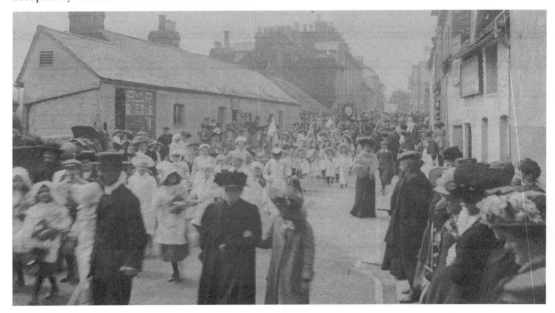

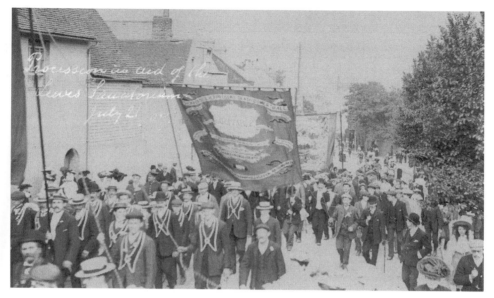

There were other quite disparate events. Above is a fundraising event in 1907 in aid of the Lewes Sanatorium (see page 79). The procession is passing by the Pelham Arms on St Anne's Hill on its way to the Sanatorium and the Friendly Societies' banners dominate the picture. Below, the procession is more subdued as local church congregations and their ministers march along the High Street and pass the Provincial Bank on the corner of Watergate Lane. They were demonstrating their objection to the Welsh Bill which was proposing the disestablishment on the Church of England in Wales and the creation of the Church of Wales.

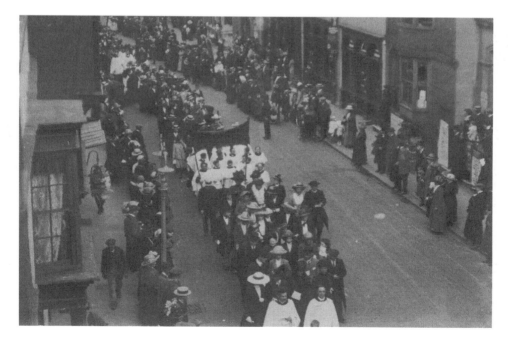

VARIETY SEASON, 1931. Change of Artistes Weekly.

LEWES THEATRE

CORN EXCHAGE, HIGH STREET.

Under the Resident Manager : Andrew Emm, Jnr.
Personal Management of – ANDREW MELVILLE.

SEPTEMBER 14TH AND EVERY EVENING DURING THE WEEK.

6.30 TWICE NIGHTLY. **8.40**
TWO COMPLETE PERFORMANCES

The Management have great pleasure in announcing that they have secured

The Celebrated Chat and Chant Comedian

REG. MARCUS

Originality, Versatility and Personality, with

BETTY DALE

Who will sing a Little, Dance a Little, and Talk a Little

The Immaculate	The Artistic and Refined
GEOFFREY CHEESMAN	**CHAS. GAY**
The 1931 Dandy	With his Concertina

The Versatile Artiste

VERA McLEAN

"Almost A Gentleman"

London's Popular Character Patter Comedian

WAL LESBY

"A Fellow of Infinite Jest"

The Musical Comedy Artistes

RENÉE and LALLA

In Song, Story and Dance

Direct from successful London Season

ELGAR & BAS

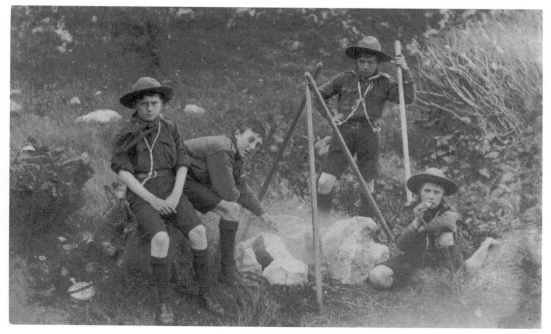

On the previous page Reg Marcus advertised bringing his touring variety show to Lewes. Others did the same including Benson's Shakespearean Company and Sanger's Circus. Lewes had the Cinema De Luxe (see page 36), the Lewes Little Theatre and Lewes Operatic Society and, until the late 1920s, the County Theatre in Watergate Lane. There were also a number of youth groups. The 1st Lewes Scout group, shown above, at their Barcombe Mills camp, was formed in 1908 and was among the first in the country. From left to right, they are Williams, Knight, Bill Hopper and Reg Barnard. The Waterloo group below is probably a Boys' Brigade.

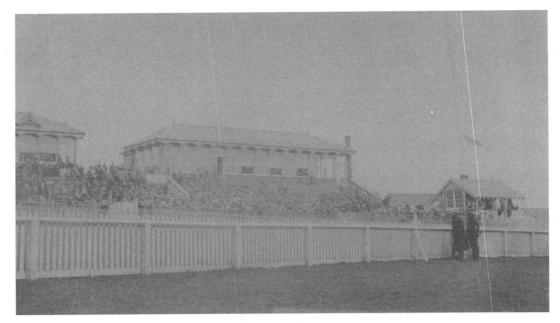

Horse racing was in Lewes for more than two centuries until the course was closed as part of a rationalisation programme in 1964. The first race stand was built in 1772 although a 1724 map shows 'horse course', and a meeting is recorded in 1751. The card above shows a large crowd at a meeting in 1907. The grandstand and other buildings have been converted in to private homes. Similarly, parts of the track remain as gallops. Below the horses are at the starting gate for a one-mile race in 1910 and probably had Lewes-based entries from one of the seventeen stables operating in the town in Edwardian times.

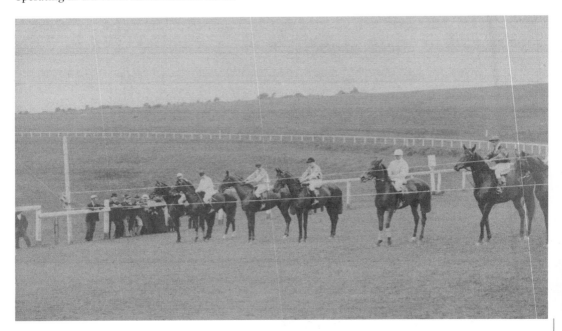

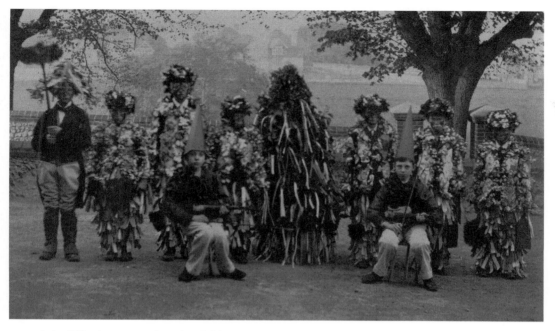

It is difficult to say what the children pictured above are supposed to be, perhaps Morris Men, Mummers or Jacks-in-the-Green, but they were part of a 1907 event, possibly the Lewes Carnival or Lewes Garland Day. As usual James Cheetham was on hand to capture this strangely menacing group. Below, in the same year, a parade enters the Priory grounds for a Country Fair. The style of dress suggests that the participants were trying to recreate the days of Old Merrie England and the Southover Bonfire Society has held a Medieval Fair on the same site in recent years.

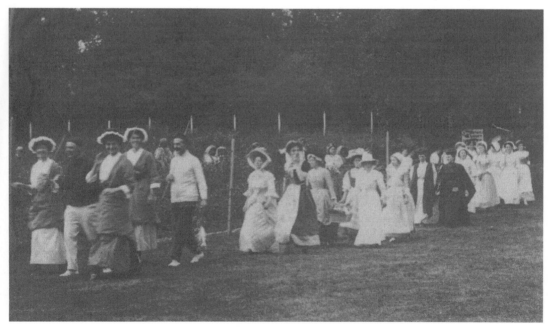

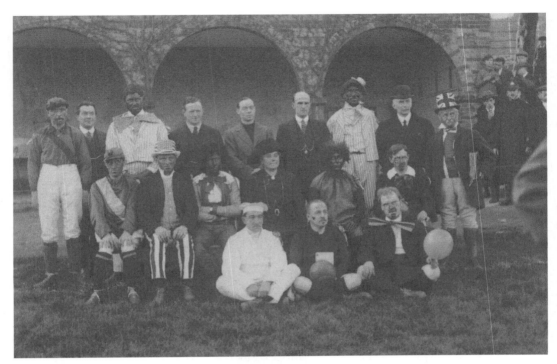

Posing by the Dripping Pan stand is a group of Lewes traders in fancy dress who played a charity match on 23 February 1921 against East Sussex Police. A crowd of 2,000 helped them raise £150 for the Victoria Hospital. Below is the main event at a track meeting held on 3 September 1908 by the Brighton and County Harriers on the Convent Field. George Larner, the World walking champion was matched with J. G. Cox, a well-known Lewes cross-country runner. Larner had to walk three miles while Cox ran four. The paper reported, 'Although the runner's pace was a fine one, he was unable to beat his antagonist and the famous policeman pedestrian won by 295 yards.'

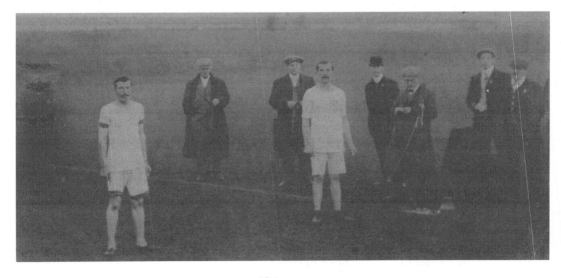

Not all members of the Lewes Priory Club were modest about winning the Lewes league in 1906/7. Jack M. has highlighted himself on the front of the card and on the reverse in September 1907 wrote, ' I have joined the team this year and have done well [...] We went to Ringmer on Saturday last and beat them 8-0 [...] could not keep a straight face all day.' The motley group of cricketers below seems more unassuming. They were members of the Sussex Yeomanry at a Houndean Camp in May 1905 and, given the boaters, bow tie, blazers and school ties, appear to be officers.

May Day celebrations have a long tradition. In the song, 'Here We Go Gathering Nuts in May', nuts is clearly a corruption of knots and, appropriately, it was the Knots of May Morris group who restarted the popular Lewes Garland Day celebrations in the 1980s. The mayor of Lewes, J. F. Verrall, had first revived the tradition in 1874 and, above, a school group in 1909 display is the garlands they have made for the May concert. The card was sent on 25 May by the mother of Maggie who is fourth from right. Below, the St Anne's Whist team, who won the Lewes league in 1912 and 1913, are just about containing themselves – as am I in having finished this book.

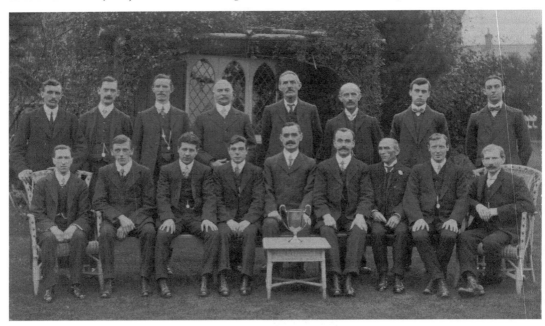

BIBLIOGRAPHY

There are dozens of books about Lewes and I have found the following particularly useful:

Brent, Colin, *Lewes Town Council Official Guide* (1995)
Cairns, Bob, *Lewes Through Time* (2012)
Cairns, Bob, *Lewes in Old Picture Postcards* (1988)
Chapman, Bridget, *Weathervanes In and Around Lewes* (2010)
Clark, Kim, *Lost Lewes* (2002)
Clark, Kim, *The Twittens* (2011)
Davey, L. S., revised by Kim Clark, *The Street Names of Lewes* (2010)
Davey, L.S., revised by Andrew Whitnall, *The Inns of Lewes Past and Present* (2006)
Etherington, Jim, *Lewes Bonfire Night* (1993)
Poole, Helen, *Lewes Past* (2000)
Wadey, Bruce, *South Street Bonfire Society* (2014)
Young, Bill, with Bob Cairns, *Lewes Then and Now* (1998)
Kelly's Directories

I also referred to these excellent websites:

www.sussex postcards.info curated by Rendell Williams
www.photohistory-sussex.co.uk curated by David Simkin

With floods of thanks to them all.

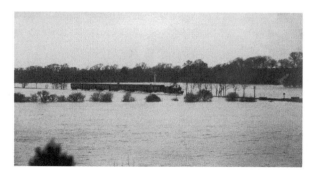